A–Z
OF
BRIGHTON AND HOVE

PLACES - PEOPLE - HISTORY

T0293964

Kevin Newman

AMBERLEY

'Many a man has been judged by his feelings for Brighton'

Barbara Willard, *Sussex* (Batsford, 1965)

First published 2020

Amberley Publishing
The Hill, Stroud, Gloucestershire, GL5 4EP
www.amberley-books.com

Copyright © Kevin Newman, 2020

The right of Kevin Newman to be identified as
the Author of this work has been asserted in
accordance with the Copyrights, Designs and
Patents Act 1988.

ISBN 978 1 4456 9221 0 (print)
ISBN 978 1 4456 9222 7 (ebook)

All rights reserved. No part of this book may
be reprinted or reproduced or utilised in any
form or by any electronic, mechanical or other
means, now known or hereafter invented,
including photocopying and recording, or in
any information storage or retrieval system,
without the permission in writing from the
Publishers.

British Library Cataloguing in Publication Data.
A catalogue record for this book is available
from the British Library.

Typesetting by Aura Technology and Software
Services, India. Printed in Great Britain.

Contents

Introduction

I am delighted to be able to follow the great work of Tim Carder and Rose Collis with an alphabetical look at the wonderful city of Brighton and Hove. *A–Z of Brighton and Hove* has no pretensions of being anywhere near as detailed or comprehensive as the *Encyclopaedia of Brighton* but is a look at the unusual, interesting and quirky sides of the city and its good (and not so good) folk throughout the past.

Who wouldn't want to write about such a happy city? Brighton was recently voted the most popular British seaside destination on the list of thirty locations people considered 'happy places'. Below Brighton was Padstow in Cornwall, which was chosen by 17 per cent as their favourite place, and the sandy beaches of the Hebrides with 17 per cent. St Ives, also Cornwall, scored 15 per cent, Blackpool Sands had 7 per cent and Fistral beach had 5 per cent of the vote. The *Argus*, Sussex's Brighton-based local newspaper, recently reported how Brighton was found to be a favourite destination among women in particular, with 23 per cent of those surveyed picking it as one of their happy places, compared to 14 per cent of men. It was also popular with sixteen to twenty-four year

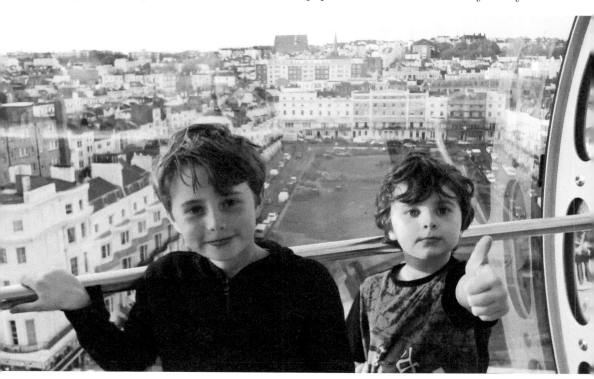

Two happy boys in Brighton.

olds, with more than one in five (the highest number for any age category) enjoying a trip to Brighton for their holidays last year. Organisers of the research said, 'In terms of culture, history and picturesque scenery, many popular European resorts could not compete.' More than one in ten people from Brighton said it also was their favourite holiday location, which shows how much people love living in the seaside city. Brightonians, therefore, even feel on holiday in the place they live in (either that or they're confused about the concept of a 'holiday').

We also have the largest city on the south coast with Hove – an estimated 281,076 people in 2014 – and we all know we're really the capital of Sussex (but don't tell the rest of 'em!). We pipped Plymouth (261,546), soared past Southampton (253,651) and prospered more than Portsmouth (209,085). We are the third largest city in the south after only London and Bristol, and total a fifth of all of Sussex's 1.6 million people. We've been the biggest town (and now city) in the county since the early 1800s. What most people don't know is that we've always been one of the largest towns in Sussex and have been the largest for two centuries. Despite popular belief, Brighton was a decent-sized fishing town, not a small village as is often thought, even back in the Middle Ages. It was given a fair and town market in 1313 and was big enough to have its own constable as far back as 1285. This all suggests people wanted – and still want – to live here because it is a brilliant place.

The city is also a city of achievements, accomplishments and firsts in times of both peace and war. The first man ever to die in a car crash sadly came from Brighton – perhaps the start of Brighton's love-hate relationship with the car. From movement of the masses to movement of munitions, Brighton was also where the first Allied soldier to fire shots in the First World War was from. Regarding movement of military matters, the man who sent the telegram to end the conflict was from Hove.

So, whether you just intend to dip in and out or travel the alphabet as a whole, I hope you enjoy this peek into the past of Sussex's 'Old Ocean's Bauble', as Horace Smith (1779–1849), a friend of the poet Shelley, called the town.

A

Albion, Brighton and Hove

Having nearly played 120 years of matches, it is no wonder that the Albion have played some bizarre opponents over the decades. One of those opponents whose tactics would sound the strangest today would be Surrey team the Corinthians, a top amateur club whom Hove headteacher Bill O'Byrne of Claremont School played for. Before Corinthians merged with the Casuals in 1939 to form the Corinthian Casuals they amazingly would deliberately *not* try to save penalties, including when they played the Albion. They would always withdraw their goalkeeper away from the goal to help their opponents. The thinking was that they had brought shame on the club in causing a penalty decision, so their opponents must be allowed to score! Despite this, the Corinthians only were beaten by Albion in a second replay when the two competed in the FA Cup of 1923.

Nobody really knows exactly why Brighton chose the name 'Albion' for its football team in 1901, following the earlier team names of Brighton United and Brighton and Hove Rangers. There was a Hove FC who first played at the Goldstone Ground before the Albion (when the Albion were playing at Dyke Road Field) and the Albion's first chairman and manager even briefly toyed with the name of 'Brighton and Hove United' before settling on the current name. 'Albion' is an ancient word for England used by the Romans that means 'white' (as in 'Albino'). The Romans used it as their first impression of the island was the white cliffs of Dover. This means the name is quite apt, as Brighton and Hove sit on (albeit low-lying) chalk cliffs similar to Dover, as does the Amex. This doesn't explain West Bromwich Albion, however, who are in the Midlands! Both clubs do play in a striped kit, though, and some fans claim that John Jackson, Albion's (and Brighton United's) first manager, had links to West Brom, though there are no records of this.

Club historian Tim Carder suggests the name was just popular at the time, with numerous businesses and pubs in the area set up using the name Albion. This seems strange though, as at the turn of the century the most famous Brighton business with the name, the Royal Albion Hotel, had closed down and would stay so for over a decade,

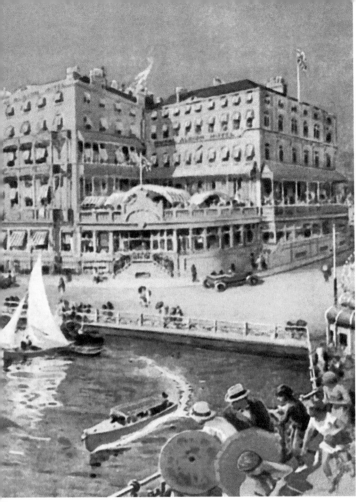

Left: An imaginative image of the Royal Albion Hotel, *c.* 1930s. Not a likely inspiration for the 'A' in BHAFC.

Below: Last ever goal being scored at BHAFC's original Goldstone Ground.

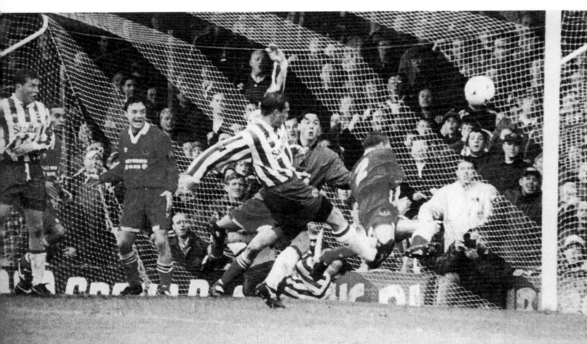

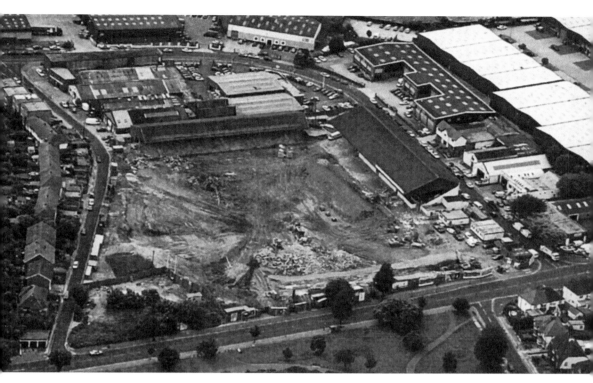

The Goldstone Ground being demolished.

so choosing 'Albion' as a moniker might have seemed a bad omen. The late Victorian age was a patriotic one, however, with the Boer War taking place, and perhaps Brighton wanted to reflect this patriotic feeling. Whatever the reason for choosing the name, Albion's name is certainly one today that means a lot to fans and hopefully one the Premier League won't forget!

The beautiful game was played at Brighton College prior to the Albion being set up, but the first site linked to the Albion are Surrenden Fields, at Home Farm, Withdean, today a park next to London Road, just south of Carden Avenue. This is where Brighton and Hove Rangers, a team who would be the precursor to the Albion, played in 1900–01. An even earlier team whose players joined the Rangers, and whose manager, John Jackson, would be the first Albion manager, existed even earlier in 1898–1900 but we don't know where they played. After Rangers folded, Jackson and William Avenell, who'd been involved with both United and Rangers, called a meeting to set up a new club at the Seven Stars pub in Ship Street on 24 June 1901, which is still there today. The staff say the meeting took place at the rear of the pub, where you can sit, and not upstairs as thought. This is a good thing for the pub's manager though, as she lives upstairs and would therefore have Seagulls fans tramping through her home! Avenell would be the club's first chairman, as well as fundraiser and even club photographer.

He was a talented man as, like Albion's Chief Executive today, he was also a barber – but by profession, not surname.

Brighton and Hove Albion played its first ever game, which was a friendly against Shoreham on 7 September 1901 at Dyke Road Field, where you can still kick a ball about today. Albion then played at what is now the County Cricket Ground in Hove until the following year, when they shared the Goldstone Ground (today a retail estate), at Goldstone Farm, with Hove FC, who were facing financial troubles. When they folded, Albion took over the ground in 1904, where they remained until 1995.

By 1975, Albion had experimented with a number of nicknames including the 'Brovions' and the club had a dolphin on its logo. This was all to change on Christmas Eve 1975 when Crystal Palace fans were chanting in a West Street pub, the Bosun (Nellie Peck's today), their nickname 'Eagles, eagles!' After one of the fans asked the very tricky question of 'What are those birds called again on the seafront?' the answer gave Albion fans the perfect reply of 'Seagulls, seagulls!' to their Palace rivals. Soon fans were making their own seagulls memorabilia and by 1977 the club was forced to embrace the new club emblem and chant, and the club's nickname has remained that ever since. Today it is hard to imagine the club without its seabird emblem, even if there is technically no such actual bird as a seagull! The type of gull we associate with the club is actually a ring-billed gull.

The last full decade at the Goldstone in the 1980s provides one more special site for the Albion. The Co-op on the Old Shoreham Road, a mile away from the ground,

The Albion in the days when you would struggle to see a seagull on the kit.

used to be the Stadium pub, and it was from here that goalkeeper John Keeley had to be fetched to play a match in 1983 when replacement goalie Perry Digweed got stuck on the A23. This was despite having sunk a few pints and still recovering from injury. In the 1990s, after the controversial sale of the Goldstone Ground and huge debts, the club returned to Brighton after a stint in Gillingham. They returned to a location near to a previous site they'd played at, the council's Withdean Stadium. Withdean was originally Marshall's playing fields, which had been used by Brighton Technical College, and also as a tennis centre, zoo and, most bizarrely, a mortuary during the Second World War! Seating only 8,850, in 2004 Withdean was voted the fourth worst stadium in the country, being beaten by Gillingham! The last site to visit is Brighton's Waterhall valley, the rival site to Falmer. Falmer is an apt site for the Seagulls as the village is itself very bird focussed. Falmer gets its named from 'bird pond' (fowl mere), a family of ducks still cross the Amex car park on their way to Rottingdean, and while you watch a match, seagulls themselves soar high above the Amex, just like the team have soared in the Premier League these last few seasons.

Finally, the Albion may not have ever featured on *The Simpsons*, but a 2008 episode more or less featured the club when the long-running animated series mocked BBC documentaries, with a BBC and 'Canal Plus' 'documentary' telling of a riot in 'Brighton, England' back in 1985 between Manchester United and 'Sussex to Northamptonshire on Leith' that started at a football match and is still going today.

The Amex, or the American Express Community Stadium to give BHAFC's Falmer stadium its full title.

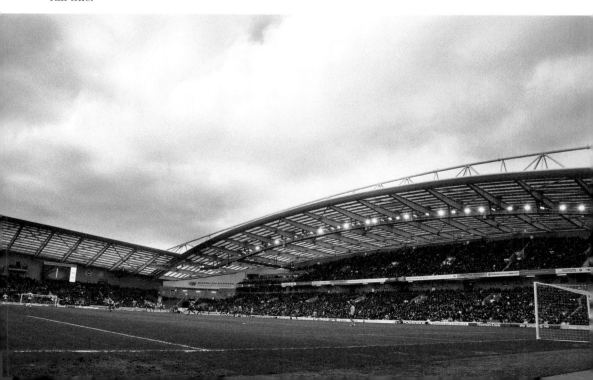

B

Beards

Brighton is the 'Beard Capital of the UK' according to the British Beard Club, which has its headquarters in Brighton. Typical of our bohemian city in the centre of Sussex, Brighton has gone against the findings in a new study that claims more than nine in ten women do not like men with beards. As reported in the *Argus* in December, half of women surveyed told a cosmetics firm they preferred their other halves clean-shaven, with 94 per cent saying they would avoid kissing a man with a full beard. We would hope for no less from a county that has a beard products company named after it in Canada. The Sussex Beard Oil Merchants sell their products around the world and its founder has even appeared on the Canadian version of *Dragon's Den*.

Birch, Eugenius

Eugenius Birch's West Pier is left in skeletal form today but it survived many storms and even legal wrangles during the thirteen decades it stood above the waves – twice as long as the earlier Chain Pier managed. The West Pier Company, back in the late

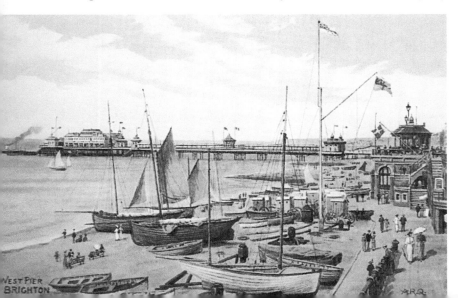

An Edwardian image of the West Pier in its heyday.

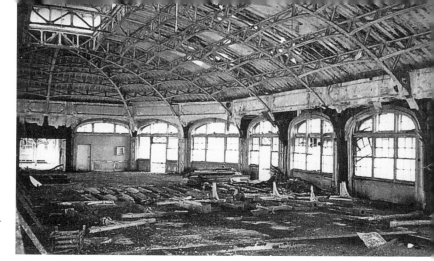

Right: The ballroom of the West Pier shortly before its destruction in the early 2000s.

Below: The West Pier experiencing its first fire in 2002.

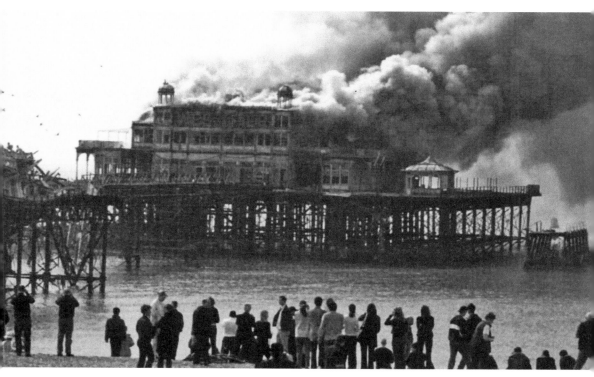

1890s, instigated a whole range of legal challenges to the then younger Palace Pier being built; eager to hinder or even stop the building of its new rival pier. The West Pier and Palace Pier both ended up damaged when our first pier, the Chain Pier, was destroyed in a storm in December 1896. This wouldn't have happened, however, if Birch, builder of the West Pier, had been allowed his scheme to demolish the Chain Pier back in the 1860s. Birch wanted to build the West Pier where the Chain Pier then stood, east of the eventual site of the Palace Pier. This would have meant we would have only ever have had two main piers and not three as we did in the 1890s. It also means the West Pier would have perhaps been called the East Pier!

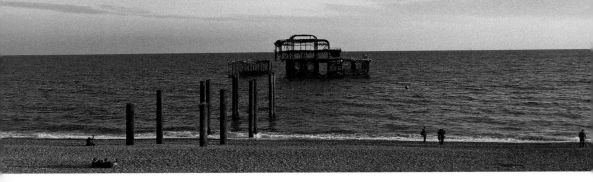

The skeletal frame of the sea end of the West Pier today.

Booth Museum

Moving inland to what once was the personal collection of Brighton nature collector Edward Booth, the Booth Museum's collection has been said to have, in some cases (literally), better displays of preserved creatures than the Natural History Museum up in Kensington. This seems pretty impressive considering that that the NHM is the work of thousands of people over many centuries, and Booth's Museum is just a collection put together just by one man solely from 1874 to 1891. It is now home to a staggering collection of 525,000 insects, 50,000 minerals and rocks, 30,000 plants and 5,000 microscopic slides. It also has shells from the bottom of a 55-million-year-old Mediterranean lagoon, and dinosaur bones. Booth's house had the Dickensian name of Bleak House and stood behind the museum on Dyke Road where Fairview, a block of flats, now stands. The man himself was a Victorian eccentric, who recorded his dog's names but not that of his wife in his diaries. He once shot at another gunner who had the temerity to come too close when shooting on the Norfolk Broads. It is rumoured that he kept a locomotive ready to steam away for an entire week to enable him to travel to Scotland at top speed for a hunting expedition. It wasn't just birds that he hunted either; apparently he was willing to fire his shotguns at the postmen on Dyke Road.

Brighton Bandstand

Brighton's seafront bandstand, located west of the West Pier, is the oldest in the country (built in 1884, ten years after Booth started his collection). Bandstands are now increasingly rare in Sussex. The county once had thirty-six but now there are only nine. This survival might be because it has been described as 'all-but bomb-proof'. It has also been voted the best in the country by bandstand enthusiast and expert Paul Rabbitts, who has written a book about bandstands. He said in an interview with the *Argus* that he liked 'the detailing of it, the design of it, the location is just incredible, the fact that there is a little coffee shop behind it, the fact you can get married in it'. He is right; what makes it unusual is that it is one of the council's licensed marriage venues. Rabbitts also liked the fact that our bandstand is unusual as it is 'right on the seafront', whereas most others are on promenades or in parks. So, bravo for our bandstand!

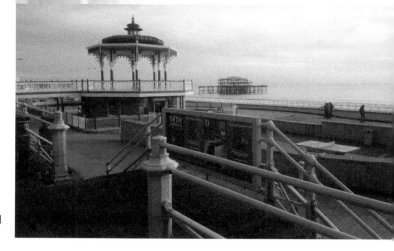

Brighton's Bandstand, loved by Brightonians, visitors and experts alike.

Brighton FC

Brighton's rugby club, the Brighton Blues, whose name Brighton FC is not a typo, as they first played as early as 1868 before the Rugby Football Union (RFU) was set up in 1871. They played rugby football on Saturdays and association football (soccer) on Sundays. In 1874, the club voted to join the Rugby Football Union and the Association (soccer) game was dropped, and they became Brighton Football Club (RFU) – although Worthing's Rugby Club selfishly demanded they still also played them at soccer. This makes them one of the oldest rugby union football clubs in the world – the twelfth. Their original name, in the days when they played against the Wasps, was the Brighton Shooflies. Brighton can boast that it invented the Great Rugby Touring industry as in December 1902 the Blues became the first English rugby club to tour France under the rugby union regulations. The gallant club met Stade Francais at the Parc de St Cloud (now Parc de Princes) and were defeated 9-3. The following year, though, Brighton had its revenge and beat Stade by one try to nil.

Brighton College

Chalk for sea defences at Hove and the harbour extension at Newhaven in the 1880s came from the playground at Brighton College. The illustrious school has also led the way with the sciences as Brighton College was the first school in England to have a science lab. Thankfully the combination of children and chemicals came long after the 1880s when the college kindly allowed hampers to occasionally be sent from home but stated firmly that 'They must not contain wine'. Other alcohol was presumably suitable. Allowing alcohol wasn't a problem in the college's earliest years though, as from 1845 until the 1870s boys were allowed a pint with lunch and another with dinner. This was halved in 1876 and in 1885 only applied to the senior boys but might still explain the two-hour lunchbreaks at this time! Should you wish to recreate these, then you might like to know that Brighton College hires out its buildings for a Victorian scholarly dining experience today.

Brighton College today.

One headmaster at Brighton College, Revd William Rodgers Dawson, perhaps let all the drink get to him. Despite not being a celebrity, he actually used to hand out signed photos of himself to the boys – could this be where J. K. Rowling got the idea for Gilderoy Lockhart from?

Another type of liquid the boys of Brighton College used was the nearby sea. They not only bathed in the sea and used Brill's Baths, but also had a mysterious rowing club whose origins, details and activities have been forgotten since its existence in the 1850s and 1860s. Adverts for the college in its early years seem strange to us in these days of thorough safeguarding of pupils. The earliest prospectuses for Brighton College in 1845 made it clear that the fees included 'a separate bed' for each boy. This hadn't always been the case back before the 1840s where it had been normal for boys to sleep two or more to a bed.

Brunswick Terrace

Peaceful and tranquil Hove was once the site of a battle between smugglers and the government's preventive men in front of Brunswick Terrace in 1835. It wasn't the only part of Hove used by 'Free Traders', as the smugglers called themselves. Hove also had two caves cunningly concealed in a chalk pit as recently as 1890 at the corner of Old Shoreham Road and Sackville Road, said to have also been used by smugglers.

Brunswick Terrace. To the west of Embassy Court was the site of a smuggling incident.

C

Chain Pier

The Royal Suspension Chain Pier, Brighton's first pier, was first proposed in 1806, built by the Brighthelmstone Suspension Pier Company by 1822 and opened in 1823. Should you wish to see a replica of this amazing construction, painted by Constable and Turner and graced by Queen Victoria, then head to Brighton Museum. Built originally as a jetty to help ships unload without the need for smaller boats, it led to Brighton becoming the busiest cross-channel port in its early days. It extended 1,134 feet over the sea but was only a tiny 13 feet wide, although its sea end was 80 feet wide and contained 200 tons of Purbeck stone. The chains that helped suspend its deck were provided by its builder, Captain (later Sir) Samuel Brown, who funnily enough owned his own chain manufacturing company. His design was so good that they kept the pier supported for seventy-three years, despite several storms before the 1896 one that finally destroyed it. Brown was also responsible for introducing chain anchors into the Royal Navy for their ships. Brighton's first pier's chains were connected to the East (Kings) Cliffs where the Volk's Railway workshop is today and were attached to 3-ton steel plates set in concrete in the cliffs. The pier was due to first be built opposite the Old Steine, but fishermen and bathers objected and so it was built opposite what

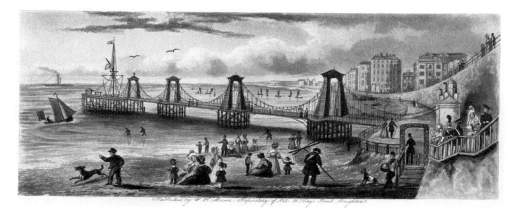

The Chain Pier by Mason. (Courtesy of the Society of Brighton Print Collectors)

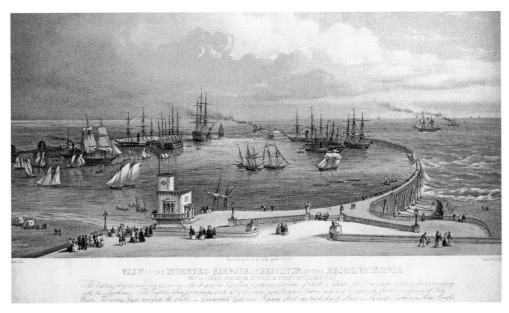

Plans to develop the Chain Pier into an embryonic Brighton Marina.

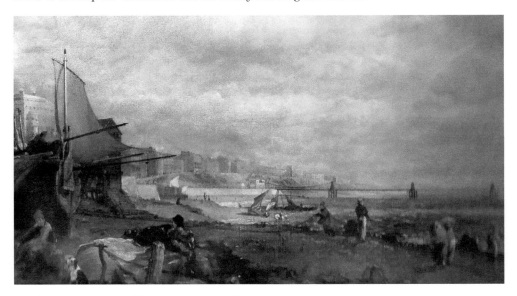

The famous painting of the Chain Pier by Turner.

became the New Steine. The pier's proposed site eventually did get a pier on it – the Palace Pier in 1899.

The Chain Pier once provided the town with the sound of gunpowder exploding: cannon were fired to signal the arrival of boats from the Continent and a bell that hung from the pier's end tower was rung. Volk's Railway, when built in 1883, actually used

to run underneath it until the pier's demise. The pier was known for its gingerbread, cherry brandy, camera obscura and portrait painters in the days before photography. Queen Victoria was offered private use of the pier in 1842 but declined and entered the projection over the sea with the public. By 1896 it was deemed unsafe and closed as it was starting to tilt and the pier head was 6 feet 9 inches out of line. It was sold to the new Brighton Marine Palace Pier Company on condition they demolish it. They wouldn't need to, however, as it was destroyed in storms on 4 December 1896. Its sundial still exists in Balcombe Church, its kiosks and cannon are on the Palace Pier but its legacy is that Brighton had what became the world's first pleasure pier and Samuel Brown's construction inspired other building works – most famously Telford's suspension bridge over the Menai Straights in Wales. Brighton's subsequent piers, the West and Palace piers, enjoy their longevity due to the lessons learnt from this first pier, and today, at extreme low tide in May, the Chain Pier's remains are still said to be visible once a year.

County Cricket Ground

To finish the ABC of Brighton and Hove sports, C is for the County Cricket Ground, Hove. Sussex's wonderful cricket ground has been at its present site in Eaton Road since 1872, before which it was a barley field. Before then it was Brighton based at what is today Park Crescent and the Level and also briefly at the Royal Brunswick Cricket Ground. During this time the ground has overcome many adversities, starting with an invasion by sheep. The first county match was enclosed by a concrete boundary, surrounded by young trees planted nearby. The sheep from a nearby field took a fancy to these and they were never replanted. The ground then survived financial difficulties in its early days, use by a forerunner of the Albion and by two schools, the Belmont and the Claremont, in the 1920s and 1930s. Its hallowed pitch also survived being used for drill practice when it became the HQ for the Cyclist Battalion of the Royal Sussex

The Sussex Cricketer pub, back when it was a hotel, at the entrance to the County Cricket Ground in Hove.

Regiment during the First World War (along with the ice rink that then existed next door). One corner was even used as a rifle range. In the next war, it was bombed twice, the first time in September 1940, causing four bomb craters and three soldiers to sadly lose their lives during the attempt to diffuse the fifth unexploded bomb. In 1942, during the second raid, the players dived for cover as a small bomb fell by the score box. The ground has even survived sheep dog trials in October 1933, prompting the wonderful old joke that, thankfully, none of the sheepdogs were found to be guilty.

Hove's County Cricket Ground has had many helpful staff over the years, but none with the footwear worn by their trusty horse back in the early twentieth century. The horse pulled the roller between innings to flatten down the turf and was clad in his very own unique pair of leather bootees. These ensured that the turf wasn't trounced by his hooves.

Churchill, Winston

Should you want a historical food or drink venue to celebrate the life of ex-Brighton and Hove inhabitant Winston Churchill then you might want to hire a suite at the Metropole, just like the ex-prime minister did in 1947 when he stayed at the hotel to

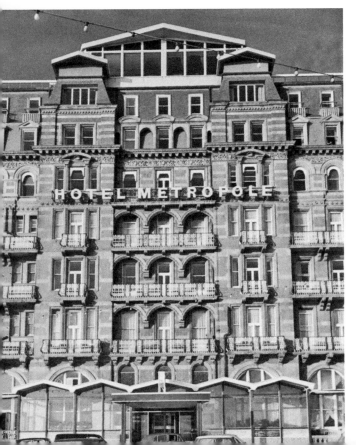

The Starlit Room at the Metropole was renamed the Chartwell Suite in a nod to WSC's visit to the hotel in 1947. It is the 1960s rooftop construction to the hotel seen here.

address the Tory party conference and be awarded the freedom of the borough. The hotel's former Starlit Room on the rooftop of the hotel has also been renamed the 'Chartwell Suite' in a nod to the wartime prime minister.

Churchill also stayed at Brighton's oldest hotel, the Old Ship, and you get to see the chair he sat in. More excitingly, though, the Old Ship hires out its ancient cellars for events so you can eat and drink where Churchill once apparently held his war cabinet and see the ancient timber from the ship that supposedly took Charles II to France during his 'Great Escape'.

Critics

There have always been the odd critics of Brighton from its earliest days. Some writers after the time of the Great Storm of 1703, which destroyed the lower fishing village, suggested Brighthelmstone wasn't worth saving and should be abandoned to the sea. Daniel Defoe wrote in 1708 that the £8,000 needed to provide Brighthelmstone's sea defences was 'more than the town was worth'. The author of Robinson Crusoe wasn't to know just how popular the town would become with writers like himself. Another man of words, Samuel Johnson, author of the first established dictionary, famously complained that Brighthelmstone was so bare a man would struggle to find a tree to hang himself in. He was so negative about the town that many Brightonians at the time must have wanted him to try! The Pavilion's construction led to a whole range of critics to complain about the building, and to try to come up with an ever more creative range of insults. William Cobbett, an MP and writer, said it was 'like the Kremlin and a series of turnips and flower bulbs [had been] placed on top of a square box'. William Hazlitt said it was merely a 'collection of stone pumpkins and pepper boxes'. Little were they to know it is now one of the country's top visitor attractions!

Brighton's Blockhouse, located here at the bottom of East Street in the Tudor era. An example of one of Brighton's many buildings that felt the impact of coastal erosion of Brighton's cliffs.

The location of Dr Richard Russell's surgery or 'hydro', today the site of the Royal Albion Hotel. This shows just how Brighton's soft chalk cliffs were threatened by the waves.

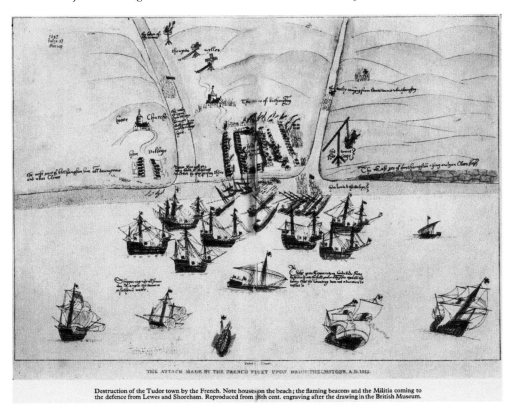

Destruction of the Tudor town by the French. Note houses on the beach; the flaming beacons and the Militia coming to the defence from Lewes and Shoreham. Reproduced from 18th cent. engraving after the drawing in the British Museum.

The earliest image of Brighton, dated 1545 but based on the 1514 attack by the French. If you look closely you can see the 'lower town' of fishermen's cottages on the beach, destroyed by the storms of the early 1700s. The King's Road runs today where this lower part of the town once was.

D

Dome

Women's efforts to win the vote before the war achieved little, no matter what the suffragists (NUWSS) or the suffragettes (WSPU) attempted. Brighton was politically ahead of the pack, with one Anne Knight writing as early as 1850 to the *Brighton Herald* demanding that the then waning Chartist movement champion not manhood, but universal suffrage. In the Edwardian era the sedate campaigning of the NUWSS

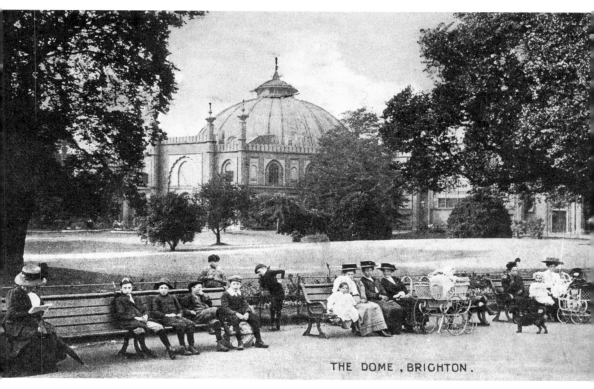

THE DOME , BRIGHTON .

The Dome, George IV's riding stables when first built, is seen here at the time of the suffragettes and suffragists.

was accompanied by the militant WSPU, with one of their first branches opening in Brighton by 1906. It gained over 150 members by 1907, two of whom attempted to sabotage a talk at the Dome by Herbert Asquith, the prime minister who had refused them the vote. The suffragettes attempted to hide in the Dome's organ ready to leap out mid-talk and disrupt the meeting but the dust within led to an unfortunate sneezing bout that foiled their plans as their hiding place was discovered.

Drivers

According to a study by insurance company Privilege, Brighton has been found as having the worst drivers in Britain. However, a story back in March 2017 challenges this claim. Radio 2 reported that a Peacehaven woman managed to make an incredible journey from her home to Hove where she was attending a dinner party and achieved an amazing bit of driving. Why was it incredible? Responsible for taking the sweet course, she had opted for a tasty cheesecake and put it on top of her car as she loaded her other possessions inside. Unfortunately, she then forgot to take the cheesecake off the roof of her car and the tasty desert managed to remain on top of her vehicle all the way along the A259, arriving safely forty minutes later.

In 1998, the local driver of a Metro was a lot less skilful. He was involved in a collision at the junction of Hove's Kingsway. His car shot through some railings and ended up teetering over of a 12-foot drop to the basement of a house in Holland Road, in the style of Frank Spencer or the coach at the end of *The Italian Job*.

E

Errors

Lady Southdown, a fictional character in Thackeray's *Vanity Fair*, was a lucky lady. Thanks to a mistake by the author, she somehow apparently managed to live at Brunswick Square over a full decade before the grand building development was built. Pictures of both the Metropole and Grand hotel have included errors over the years that serve to bamboozle the viewer or confuse them. An Edawrdian advert for the Met has the Downs right behind the hotel and the Grand Hotel managed to move to be next to the West Pier on a cover of the Brighton Quadrille, a set of sheet music. The Civil War led the future Charles II escaping to France via Sussex in 1651 and many reports of places he stayed at have been mistaken over the years. The author William Harrison Ainsworth even focused his novel, *Ovingdean Grange*, on the incorrect assertion that Charles stayed there on his journey. Ainsworth then even sent Charles far further east than he ever journeyed, having him stay at the Star Inn in Alfriston, miles away from his most eastern overnight stay, which was Brighton. The most confusing Brighton advert though must be the 1980s one to 'Make it the Met' where the weary traveller making his way to Brighton seems to have a levitating car out to sea, judging by the car's position.

This early twentieth-century image of the Metropole uses artistic licence to juxtapose the hotel right in front of a rather mountainous-looking South Downs.

Fans

We mentioned critics earlier, but those praising Brighton have always been far louder and more numerous than our detractors. Edmund Gilbert called the town 'The most attractive seaside resort in the world'. Harold Poster (pronounced as in 'Foster'), owner of the Metropole, Bedford, Norfolk and West Pier in the 1960s and 1970s, once said, quite wonderfully, 'Nothing is too good for Brighton'. Clifford Musgrave, Brighton author and curator of the Pavilion, called Brighton: 'A pleasure city ... unique on the face of the Earth'. The author William Makepeace Thackeray sang the town's praises as a friendly place that healed the sick: 'One of the best of physicians is kind, cheerful, merry Dr Brighton', hence the name of the (currently closed) pub next to the Queen's Hotel, dating back to 1750 (it was called the Star and Garter before that and is Brighton's oldest seafront pub). Horace Smith, a friend of Sussex's famous poet, Shelley, called the town both 'the queen of watering places' and the 'old ocean's bauble'. If seeing Brighton as the capital's coastal sister is positive, then nicknames such as 'London-by-the-sea', 'London's sea-suburb' and the more bizarre 'London-Super-Mare' are also affectionate descriptions. Brighton was clearly loved for its healthy air, as it was often called 'London's lungs'. Even fictional characters praised the town, with Lydia Bennett in Jane Austen's *Pride and Prejudice* saying how 'A visit to Brighton comprised every possibility of earthly happiness.' The nicest thing ever written about Brighton, though, must be on a postcard that warmly said 'Did you ever see anything in London to equal this?'

Film Locations

Peacehaven Cliffs are not just where the world-famous Meridian Line leaves our shore, but also a backdrop for several famous movies, novels and a television programme. At the finale of the 1938 novel *Brighton Rock* by Graham Greene, Rose and her gangster husband Pinkie, having just wed, drive to the town, with Pinkie planning Rose's demise. His plans go awry however, and he falls to his death from the cliffs, having been blinded with vitriol. Moving to 1979, the film *Quadrophenia*'s final scenes are also on the cliffs, with the main character Jimmy (played by EastEnders' Phil Daniels)

The *EastEnders* cast when filming on location in Brighton and Peacehaven in the 1990s.

presumably driving his idol, Ace Face's scooter off the cliffs after finding out Ace Face (played by Sting) is only a Bell Boy at the Grand Hotel in Brighton. However, we are never sure whether Jimmy does truly scoot to his death in the ambiguous ending of this classic film. Fast forward another twenty years to 1999 and a dramatic scene was supposedly shot again on the cliffs, but this time for the small screen. EastEnders had a special episode where Tiffany's ashes were supposedly spread across the cliffs. Despite the fact soap that fans had been told she'd been happy during childhood holidays in the town and the action was taking place there, the BBC bizarrely decided to film the scenes instead in Seaford, possibly as traffic noise would have been quieter.

Peter James's fictional Brighton-based detective Roy Grace has also nearly plummeted to his death on Peacehaven's cliffs. So, for a place called Peacehaven, a lot of excitement and misery has been filmed in the town, which is why it is good that comedian Rowan Atkinson filmed a more light-hearted episode of Mr Bean on not just the cliffs but also the beaches below. Residents probably needed his unique brand of cheering up after all the fictional doom and gloom set in the town.

Film

Two of the UK's oldest cinemas are in Sussex – the Duke of York's Picture House in Brighton, which opened in 1910, and Worthing's Dome Cinema, which opened in 1911 – so it's not surprising that the earliest developments in cinema and films also took place here. William Freise-Greene, early cinematography pioneer, carried out a number of his experiments in Brighton and Greater Brighton around 1900, where the modern movie was created – years before Hollywood was up and running. The long hours of summer sunlight, lack of London smog and fresh air attracted a group of people in this new experimental industry to Brighton and nearby Shoreham: the film-makers. The group, led by George Albert Smith, who'd been a Brighton impresario of traditional theatre shows, even invented the technique of the first ever close-up shot in his experimentation. They also started the bold new move at this time of moving the camera. Brighton and Sussex have remained, ever since, a popular location for film-making.

Fires

The French raid of 1514, when the town was burnt down, wasn't the only time Brighton has suffered by flame. Our architectural wonders have variously faced a fiery destruction, and sometimes in suspicious circumstances. Firstly, our priceless Hove Town Hall (built by awesome architect Alfred Waterhouse) was hastily demolished after a fire. Secondly, the wonderful Bedford Hotel, (built in 1829 and cherished not just by Dickens, but beloved by architects as Brighton's most precious hotel) also went up in flames, at a time its owners strangely wanted to demolish it. The 1960s seemed to be the decade where unprofitable buildings (or those the owners wanted to demolish) mysteriously went up in flames so they could be rebuilt. In the case of the Bedford (the Holiday Inn today) and Hove Town Hall, both were replaced by far less tasteful 1960s and 1970s buildings.

Thankfully, although our wonderful hotels the Metropole (pictured), The Waterfront (was the Hospitality Inn then) and Royal Albion have all had fires, they were all luckier and survived them in 1959, 1991 and 1998 respectively.

The Metropole's exhibition and conference complex today even has a couple of Georgian houses worth over a million pounds each, which have been hollowed out to become the city's most expensive fire escape! A fire for Brighton's biggest exhibition and conference would be embarrassing for the location of numerous party-political conferences today, but the most embarrassing fire in Brighton's history must have been St Peter's Chapel in Preston, which caught fire in 1906 due to cheeky choirboys smoking!

The most famous Brighton building to be affected horribly by not one but two suspicious fires was the West Pier – and in this case not rebuild afterwards.

Below left: The original Bedford Hotel on King's Road, built in the 1820s and beloved by Charles Dickens and royalty.

Below right: The less loveable 1960s Bedford Hotel, which replaced the original after a fire. It is now a Holiday Inn.

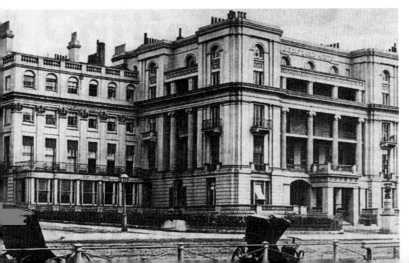

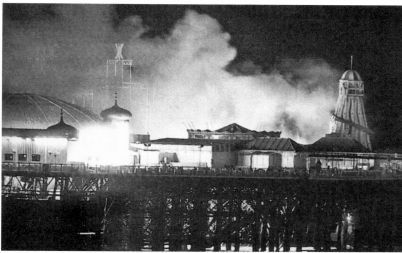

Above left: Brighton's most expensive fire escape, hidden in two Georgian town houses at the back of the Metropole.

Above right: The Palace Pier Ghost Train on fire in 2003.

However, the Palace Pier hasn't been immune from fires either. Its ghost train became scary for the wrong reasons in the early 2000s when it caught on fire. It's been a lot luckier than Worthing Pier, though, which has famously been blown down, burnt down and blown up. Fire has a more positive role in Brighton today, thankfully. Our wonderful non-religious and non-denominational Burning the Clocks event is a unique celebration of the end of nights getting longer every year and got to celebrate its twenty-fifth year in 2018.

Fishermen

Worried about Dunkirkers? How is your hoggy? Been to a Dutch auction? How hot are your dees? Is it you who 'has 'em?' Have any Brightonians experienced bending in?! If you recognise any of these words then you would have played your part of the wonderful language of our fishermen of yesteryear. Dunkirkers were foreign, dangerous fishing or pirate sailing vessels. A 'Hoggy' or 'hogboat' (pictured) was a small Brighton fishing boat that could be hauled up the stony beach easily. A 'Dutch auction' meant that fish would be sold in the Dutch style – with a high price first, then reduced, rather than the other way around. If you were successful in bidding, then the auctioneer would shout that you 'has 'em!'. Dees were fires that herring were smoked upon in Carlton Row, another fishing area the other side of the Steine (once a fishermen's working area) and 'bending in' was the benediction, a blessing local priests would make for the fishermen on their boats to wish them a safe journey and return.

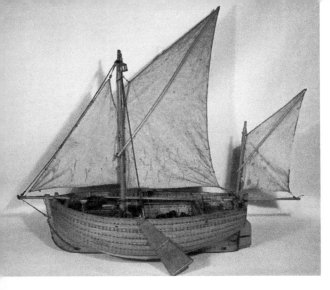

Left: A hoggie (a Brightonian fishing boat).

Below: Brighton's past fish market on the seashore under the West Cliffs.

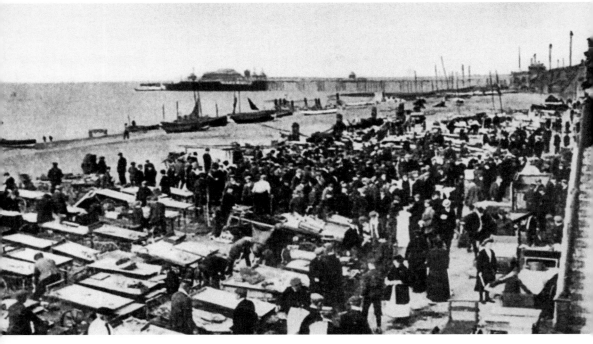

Food

Fish wasn't the only foodstuff Brightonians have eaten throughout history. Excavations at the Stone Age camp at Whitehawk Hill hinted that Brightonians of the late Stone Age were possibly cannibals due to cooked fragments of skull and also, more frighteningly, that the hilltop dwellers seem to have thrown their dead bodies out with their rubbish.

Foredown Tower

Foredown Tower is a bit like a cat that has had many fascinating lives. It started off life as the water tower of Hangleton Isolation Hospital up on the Downs above Portslade but was separate from the town in those days. Today thousands of us drive past it on the A27 every day. When it opened in 1883, the hospital dealt with several infectious diseases, including even smallpox, and the theory of the day was to keep these patients isolated – almost imprisoned – in hospitals away from the populations. The population of the hospital expanded so a water tower was added in 1909. Foredown Hospital (as it was known), closed and became a home for severely disabled children. The people of Hangleton and Portslade rallied round to save of the tower when the hospital was demolished, and it was saved in 1991 when it reopened as a countryside and astronomy centre. The fantastic 360° views across the downs made the purchasing of a camera obscura for £30,000 from the recently finished Gateshead Festival a bit of a must. The new centre attracted many weird, wonderful and worldly visitors and was Brighton and Hove's i360 of its day. Astronomy classes, run by local legend Mike Feist, still continue today. Today it is also an adult learning centre and part of Portslade's PACA school. For an interesting slice of the history of the western side of Brighton and Hove, as well as fantastic views of the Downs, not to mention the biggest camera obscura in the South East, a diversion off the A27 at Portslade is a must.

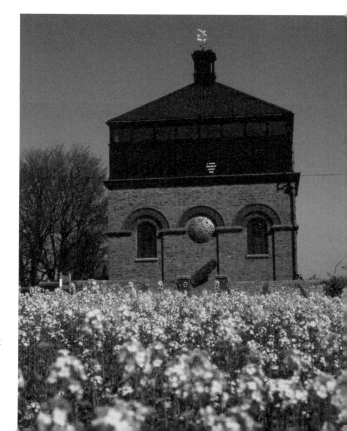

Foredown Tower, Portslade. Once part of an isolation hospital, today it is an interesting place to visit.

Gardens

Brighton and Hove's public parks and gardens have a number of surprises in them. Firstly, the Royal Pavilion grounds has some of the city's rare collection of elms and is the only completely restored Regency garden in the country. It also once had an old woman who lived in a tree. Back in the 1970s, one of the two oldest trees in the grounds of the Royal Pavilion had become not just so wide but also hollow enough that an old homeless lady made the inside of the trunk her home. Since then, the tree's holes, through which she accessed her home, have been covered with grids to stop other enterprising (and similarly tiny) homeless people copying the like of Moonface in Enid Blyton's Magic Faraway Tree stories and making a woody space their sleeping place. The tree itself (on the south side of the gardens) is still well worth a look and has to be kept deliberately short to stop it becoming too heavy and collapsing. One Brighton legend is that Charles II also hid in the tree while hiding from Parliamentary soldiers when on the run in the town in 1651. Due to Dutch elm disease back in the 1970s, Sussex now boasts having the largest collection of mature Elm trees in the country and its 'Preston Twins' in Brighton's Preston Park were widely considered to be not just the largest but some of the oldest elm trees in the world, so it was a great shame when one had to be cut down in 2019 due to disease.

George IV

No book on Brighton can omit one of the figures whose patronage of the town caused so many others to emulate him and take residences here by the sea – King George IV. The king brought much (admittdly taxpayers') money to the town and undoubtedly helped fuel its rapid expansion from a small fishing and farming town. However, his visits from 1783 onwards were not without a price to pay for ordinary folk. The local soldier firing a town cannon in Brighton to welcome Prince George's first visit to the town in 1783 got his arm blown off, and George's pastimes included using the Steine as his personal shooting range. Several of the chimney pots were riddled with bullets as a result of George's antics. The prince was also responsible for the lowering of the property of the Honourable Mr Windham of the Steine, whose chimney tops he shot off when practicing shooting outside his Pavilion. Apparently, some bullet holes still remain.

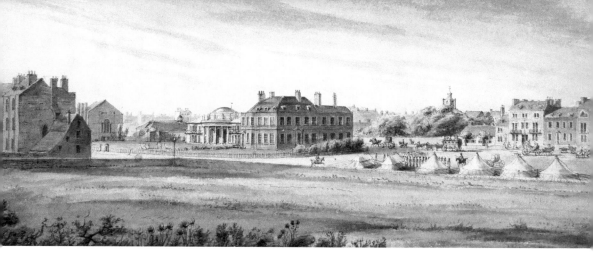

The Steine in the early years of Prince George/George IV's visits to Brighton. The Royal Pavilion is shown here after its first rebuild as the Marine Pavilion and the Castle Hotel can also be seen to the left of the Pavilion. (Courtesy of Royal Pavilion and Museum, Brighton and Hove)

George was even willing to cause discomfort to those he was fond of by making the practical jokes that he loved. He was also the butt of the odd joke too. Admiral Sir Edmund Nagle was in charge of the ships defending Brighton by sea, which he usually commanded from the Old Ship's dining room. Nagle loved the prince's cream-coloured horses so the prince gave him one, except it was one of the admiral's own multicoloured horses painted to look cream coloured. The admiral soon discovered the trick during the next Brighton downpour. The prince's friends, the Barrymores, loved a good party and loved swapping road signs around back home near their country estate in Ireland. Back in Brighton, their typical activities included throwing bottles of port at each other in the Old Ship. One of the Barrymores rode his horse up to the attic in the prince's mistress, Mrs Fitzherbert's house in the Steine, and only a pair of blacksmiths were able to coax the mare back out. They scared locals by leaving a dummy corpse in coffins on people's front doors, which would fall on them on opening. George himself was the butt of one of his friends' greatest jokes. He awoke with a fright to find a donkey wearing a pair of devil's horns and decorated with numerous firecrackers looking up at him while in bed. George obviously wasn't too frightened of the asses though – he led a 'regiment' of them at a military function once. He also created a military scare by managing to make the local cavalry think the French were invading, and the bathing women and fishermen on the beach thought the charging cavalry men were also French, and so attacked them with fishing nets and broomsticks.

On the subject of food, George was known for his excessive waistline and ability to gorge himself on banquets at the Pavilion, which could have as many as 110 courses. One record-breaking meal was even provided for the prince from a Sussex river. A gargantuan trout given to the Porky Prinny to consume weighed an incredible 22 lbs. That probably kept the rotund royal fed for half an hour!

George IV was responsible not just for the demolition of Brighton's major Castle Hotel, which once rivalled the Old Ship for size and grandeur, but the relocation of a chapel next to it in North Street. He also diverted East Street, which went past the

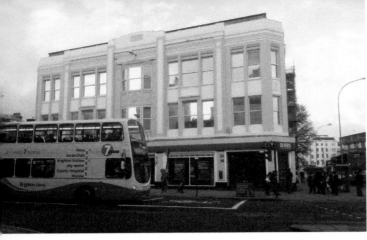

The site of the Castle Hotel today in Castle Square.

The Steine here following the New Year's Eve celebrations of 1999. Probably not as bad as it would have looked following George and his chums' drunken shenanigans back in the late eighteenth century.

Pavilion, and rebuilt it as a new road through Promenade Grove Pleasure Gardens to become what is now – New Road.

Green Man

Brighton has always been known for its green credentials, with the country's first Green Party MP, but one man took this to extremes back in the early 1800s. A man by the name of Cope was referred to simply as The Green Man and seemed to be known by nobody but witnessed by everyone at the time. He dressed in Green Pantaloons, green waistcoat, green frock, and green cravat, which all reflected to make him look green all over. Years before vegetarianism (nobles in the Middle Ages thought veg made you ill) he ate nothing but greens, fruits and vegetables. Even his habitat was green: he furnished his rooms green, had a green sofa, green chairs, tables, bed and curtains. Even when out and about his gig, portmanteau, gloves, livery and whip were all green. It didn't stop there, he had a green silk handkerchief, large watch chain with green seals, which was fastened to his waistcoat's green buttons. If only he had met Diane Moran, the Green Goddess of 1980s BBC Breakfast Time ...

H

Harry Pointer and the Goblet of Felines

Brighton never featured in the Harry Potter films (the Seven Sisters did, however) but it did once have a Harry Pointer, who moved here and made his living as a drill sergeant and eventually a portrait photographer. He found fame as a photographer of cats and would have them posing on top of books, in mixing bowls, kittens in cups and moggies balanced on a watering can. The images started to become more peculiar and he would arrange his cats in unusual poses that mimicked human activities – a cat riding a tricycle, cats roller skating and even a cat taking a photograph with a camera. They would be encouraged to show different cat emotions – anger, excitement and even resentment. Over 200 images were taken and sold before the photographer moved onto dogs. The photos now became more ambitious still and even stranger. Two of his photographs, named 'The Jubilee, 1887', featured cats and dogs (not together!), the first showing '50 Dogs' Heads', and the other called 'Fifty Cats', with each animal representing a year of Victoria's reign. His most ambitious and unusual picture was even more ambitious. It was called 'Home Rule' and included nineteen cats, six dogs, three foxes, one monkey, and a piece of roast beef. This certainly meant he had knowledge of fantastic beasts and where to find them. Pointer had his studio in Brighton, bizarrely at Bloomsbury Place. Harry Potter was, of course, famously picked up after numerous attempts by J. K. Rowling by a publisher called ... Bloomsbury.

Hollingbury Castle

The land high above Brighton at Hollingbury, sometimes known as Hollingbury Castle, is where the earliest Brightonians were buried. This is in a causewayed enclosure, which was some sort of camp for feasting and rituals but not, it seems, for military defence. The camp is over a thousand years older than Stonehenge. The discovery of an eight-year-old and a young woman along with her newborn child told us much about the Neolithic part of the Stone Age (*c.* 4000 BC–2500 BC), but also provided us with secrets we may never answer, such as why were they buried; did they die of natural causes and why were they buried with animal bones and other rubbish? Was this a

punishment for a young mother back then at a time when children were lucky to make it into adulthood? The fact the mother was buried with an ox bone, two fossil sea urchins called shepherds' crowns and two chalk 'pendants' with holes drilled in them perhaps suggests otherwise; these were probably good luck talismans for the afterlife. If you want to make your own mind up then the remains are in Brighton Museum.

Holes and Hatches

Brighton still has a hatch at the Theatre Royal where actors were served pre-performance Dutch courage from their own private bar. Lord Olivier was a well-known customer. The Queensbury Arms in Queensbury Mews, next to the Metropole, was once renamed the Hole in the Wall as it served fishermen who were too whiffy

The hatch in the Theatre Royal through which actors were served drinks to provide Dutch courage before a show, including Lord Olivier.

The Queensbury Arms in Queensbury Mews – formerly the Hole in the Wall.

The Kingswest Boulevard, home to Brighton's Odeon Cinema and complete with later added window.

to enter the tiny pub, and so got their drinks also served through a hole in the wall. Brighton's Odeon once had an open upstairs bar, which was created when complaints were made about the fact the hideous Kingswest Boulevard building the Odeon is now in had no windows. Having a building facing the sea with a massive concrete frontage and no windows made locals mad, so the owners cut a hole in the front and put a small glass front in, which then provided one of Brighton's best views in a building that was decidedly not the best view to look at.

When the new Hove Town Hall, which opened in 1974, was being built workmen digging the foundations discovered water 40 feet below the surface. They initially believed it was water that had flowed down from the Downs, but it turned out to be seawater that had made its way inland, although the Town Hall was actually 400 yards back from the sea. As recently as 1890 a chalk pit existed by the junction of Old Shoreham and Sackville Road, which concealed a cleverly disguised entrance to a double cave – one leading to the other. It was believed to have been used for smuggling.

Hove

Despite years of fears about a merger between Brighton and Hove, the coming together of the two towns helped the bid for city status and reflected the fact that there was never really that much dividing the two. Brighton had the fame and history, and Hove the respectability and yet more fantastic architecture, making the pairing mutually successful. Like Brighton, it had a number of earlier names such as Hoo, Hou, Hova and Hoove and was never as much of a mouthful as its neighbouring Brighthelmstone to pronounce. Hove was already a decent-sized village by Norman times, with one street running north from where the crossroads by King Alfred is now. Like Brighton, it too was partly washed away by the sea, but its cornfields developed into graceful squares and terraces as Brighton stretched outwards and the two were joined by the 1800s. Its buildings were so desirable in some of its areas like Palmeira Square and Adelaide Crescent that Brightonians tried to refer to them as West Brighton. It had the title 'Montpelier of the South' and got a charter as a municipal borough in

1898. King Edward VII visited Hove as well as Brighton, stating 'I like Hove, I like its surroundings and I like its climate.' Today Hove provides more than just population to its part of the partnership with Brighton. It provides a different but equally charming seafront, complimentary alternative shopping, eating and drinking experiences and a wonderful western side to our joint city.

Hove (Old) Cemetery

Hove has two cemeteries, but it is the old one (south of the A270) that is worth visiting if you want to pay homage to First World War hero Bernard Norris Butcher, who died in 1921 alongside numerous other casualties. Bernard has had one of the rooms at Portslade town hall recently named after him. This accolade is due to his award in 1916 of the Distinguished Conduct Medal (DCM) 'For conspicuous gallantry on the 29 January, 1915 at Cuinchy [Northern France]. During an attack ... he, while under heavy machine-gun fire, bombed the enemy, and was largely instrumental in defeating the attack. He has, on many occasions throughout the campaign rendered valuable service and has invariably shown great courage, resource, and devotion to duty.'

Butcher's courage and leadership under fire continued and on 27 September 1916, he was awarded the Military Cross, 'For conspicuous and consistent gallantry and good work. On one occasion, after all his officers had become casualties, he kept his company together, so that it rendered fine service later in the day. On another, when the battalion had suffered severely, his energy and cheery pluck were invaluable.'

The focus of the attack at Cuinchy in France was known as the 'Brickstacks', which was an area of land in Cuinchy, and photographs of the time show a flat landscape with built-up large blocks of land, which are raised up like mini strongholds. It was like no other area on the front line in the First World War and the front line did not move for most of the war. Both sides were fully entrenched. It sat on a flat piece of

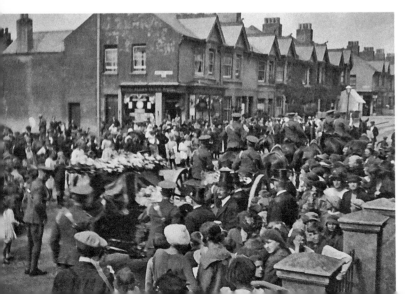

Bernard's funeral procession, 1921. (Courtesy of Robert Butcher)

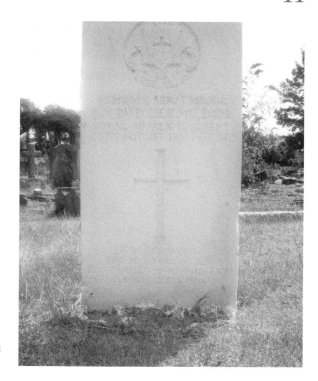

Bernard's grave in Hove's Old Cemetery today. (Courtesy of Robert Butcher)

land between the towns of Bethune and La Bassee. The trenches were often filled with water. The nightmare of the place is summed up by this quote from Robert Graves in *Goodbye To All That*:

'Cuinchy bred rats. They came up from the canal, fed on the plentiful corpses, and multiplied exceedingly. While I stayed here with the Welsh, a new officer joined the company ... When he turned in that night, he heard a scuffling, shone his torch on the bed, and found two rats on his blanket tussling for the possession of a severed hand.'

The German attack on the 1st Division at the Cuinchy, when Butcher earned his first medal, was launched on 29 January 1915, and the Royal Sussex Regiment to which Butcher belonged was surrounded after a vigorous German advance. They had taken refuge on the Brickstacks themselves, which were known as 'the keep', and were now surrounded by the German soldiers. The casualty rate for officers was very high and on the morning of the 29th the last officer had been shot through the head, leaving Bernard, acting company sergeant-major, as the highest-ranking soldier. The German troops advanced on the Brickstacks and tried to storm it with the aid of scaling ladders and axes. One contemporary report proudly talked of Bernard by his nickname: 'Solid Sussex ... inside the Keep, ... [ensured the German] ladders and stormers were hurled to the ground, whilst bombs were thrown on the heads of the attackers'. On the date of Bernard's citation the report states: 'During an attack on the Keep, he, while under heavy machine-gun fire, bombed the enemy, and was largely instrumental in defeating the attack.'

The words speak volumes. While there were other regiments in the area and other men, the day seems to have been held by Bernard and his remarkable courage and strength of personality shines through from the past. The DCM is often considered a near miss for a Victoria Cross, and has to be, in most cases, recommended by an officer and three witnesses – as you will recall there were no officers left to recommend Bernard for the VC. Had there been so, then surely Portslade would have its own holder of the VC. Bernard Butcher was taken sick in the Caribbean after the war and died in 1921. He may not have received the VC but he did receive the MC and DCM so we should toast him today.

Hove Pier

Hove once had plans for its own pier to rival Brighton's two (briefly two and a half), which was to be opposite Adelaide Crescent. The plans were drawn up in 1864 and being Hove it originally was to be ornamental rather than for entertainment. Brunswick Square commissioners were originally in favour but changed their minds by 1865. Hove didn't give up though and more plans were proposed in 1887, 1892, 1911, 1914, 1923, 1930 and finally in 1932, although the proposed location changed, with another site proposed between Forth Avenue and Albany Villa. The 1930 plan wanted the pier to be opposite Sussex Road. The pier, had it been built, could have had some amazing features. It was to give Hove it's own theatre and a health spa below the pier. For a building sat on water, its plans featured something not always wise to mix with water – electricity. There would be hydro-electric baths, electric light and x-ray treatments. The Pump Room would supply mineral waters from every spring in England and abroad – obviously Hove's seawater wouldn't do! Most grandly, there would be an electric tramway running from the shore to the end of the pier.

Hove Town Hall

Hove's 'concrete carbuncle' was the first new town hall to be built in Britain after the war. It was completed in 1974, yet within months cracks were developing in the concrete structure. By 1978 contractors were brought back in to repair cracks. By the 1980s there was no longer enough room for all the staff so the building had to be developed further and the new block was hugely hot in the summer (111F was recorded in 1989) and staff froze in winter. This then cost a further £16,500 to sort but by 1990 the building was still seen as too small and another £380,000 (millions today) was spent increasing the size of the Town Hall further. Perhaps Hove should have just repaired the beautiful original Alfred Waterhouse-designed Victorian town hall that existed before it, which could have been done – and expanded that as needed? The name Hove Town Hall now has been officially discontinued since 2001. It is now just the Hove Centre.

I

i360

The i360 is the largest moving observation tower in the world and it is on the site of the West Pier, whose kiosks were the largest ever to grace a seaside pier when built. Today the i360, which opened in 2016, has replicas of these kiosks. The i360 can be hired out, but on ordinary 'flights' (as the i360 call them) you can enjoy the views and the Newtimber Sky Bar, which serves all kinds of drinks but especially the local Sussex vineyard's sparkling wine.

Foundations of the i360 being laid in 2015.

The i360's
pod being
constructed.

The column of
the i360 being
constructed.

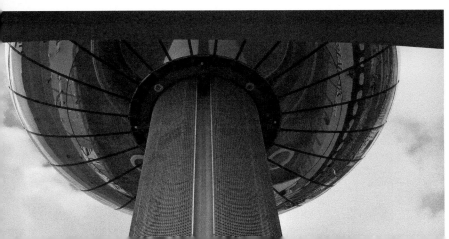

The i360 taking
flight.

View No. 1 from the i360.

Above: View No. 2 from
the i360.

Right: The Newtimber
Bar on the i360.

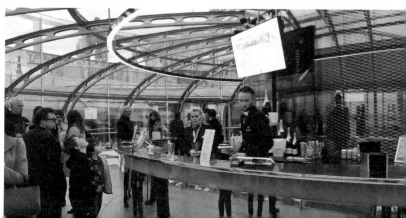

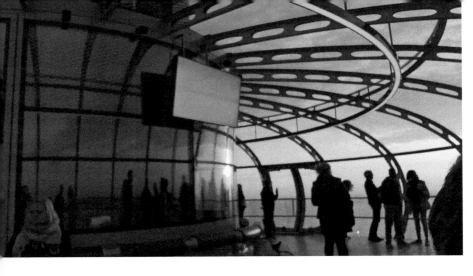

The interior of the i360, an ideal Brighton spot to watch the sunset.

India Gate

The people of India in 1921 paid for the southern gateway to the Pavilion to be replaced by a new gateway, the India Gate. This Indian-style gateway replaced an earlier southern gateway to the Pavilion grounds in 1921 and was a memorial to thank the people of Brighton for their care for India's wounded soldiers between 1914 and 1915. Today it ensures the people of Brighton don't forget the bravery of the million Indian soldiers who fought, and in many cases died, thousands of miles away from home. These soldiers had given so much and still wanted to say thanks for their care so it was more than fair that His Highness the Maharaja of Patiala, officially unveiled the gate on Wednesday 26 October 1921, was presented with a gold replica key to Brighton's most famous Indian-style building – the Royal Pavilion.

The India Gate, India's thank you to Brighton following the First World War.

J

James, David and Peter

Kemp Town's MP in the 1960s, David James, when not being the Tory MP for his constituency, set up the Bureau for the Investigation of the Loch Ness Monster.

All crime fiction fans will know that Brighton is the home of internationally famous fictional Detective Inspector Roy Grace, in the series of detective novels written by local author Peter James. Peter is one of Brighton's biggest celebrities as well as a multimillion selling author worldwide. His books are regularly in Britain's top 10 list of bestsellers and ensure people worldwide read about Brighton. Over 20 million copies of Roy Grace novels in thirty-six languages have been bought throughout the world, bringing Brighton's locations to far-flung places. In 2012, Peter got the chance

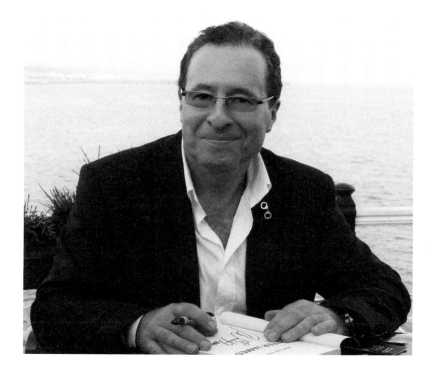

Peter James, bestselling novelist of the darker side of Brighton.

to inflict pain on Christian Grey when *Not Dead Yet* managed to finally topple the *50 Shades of Grey* trilogy off the No. 1 selling paperback slot, after twenty-five weeks. Roy Grace and his team have so far caught dozens of murderers, saved numerous lives and had multiple hangovers. Peter has ensured that many Brighton locations have gained fame from his novels, with Roy nearly falling to his death at the cliffs at Peacehaven, getting married (twice) at the church in Rottingdean and taking part in a dramatic chase near Shoreham Airport. Peter is currently overseeing the adaptation of his bestselling Roy Grace novels to TV.

If the activities of the first Mr James above weren't odd enough for you, then Jury's Inn hotel by Brighton station have tried to home in on Brighton's quirky nature by opening up a bar and restaurant called Oddsocks, where the staff all wear odd socks.

Shoreham (Brighton City) Airport, scene of an exciting Peter James Roy Grace chase scene.

K

Kingswest Boulevard

The name of the building the Odeon and Prysm inhabit today must be Brighton's most misleading, not being a boulevard (street) but a building, and seemingly taking the names of the two streets it is on the corner of. This bonkers building has also been called the Top Rank Suite, in the days when people went 'up town top ranking'. The name is as daft as the building itself, which doesn't have windows in a position facing the sea where people normally like a sea view. Its roof was rumoured to have been to replicate a floating spaceship design when built. Now of course it is home to the Odeon Cinema, which, as a cinema, still needs no windows. The rest of the building remains a concrete monolith in an area of detailed and intricate Victorian architecture and there have been calls to demolish it since it was completed. The only good thing about the building is that it was originally meant to be part of a massive 1959 plan to demolish acres of Brighton as part of the original Churchill Square designs. The plans included the demolition of one Grand Hotel, replacing it with an amusement arcade, but they never saw frutition thankfully.

The Kingswest Boulevard, Brighton's most unloved building, here seen on the corner of the two roads it takes its name from – King's Road and West Street.

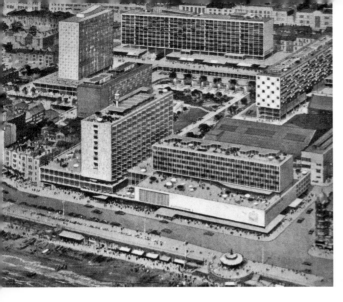

The 1959 plans for the redevelopment of Brighton, featuring the Kingswest Boulevard (as seen in bottom right-hand corner). Thankfully this was the only bit of this damaging redevelopment that took place.

King George's Buckles

King George IV is the most famous king linked with Brighton, followed by Charles II and Edward VII. However, he was also probably the worst person to ask in Sussex for economic or business advice in the late eighteenth and early nineteenth century judging by Mrs Fitzherbert, his beloved wife. She revealed that he had a pair of shoe buckles for every day of the year. His buckles apparently covered an entire table of the Pavilion.

Knabb

'Knabb' is a Viking and Saxon word meaning 'small hill', which gives us the name of the Knabb in the Lanes in Brighton, where the Pumphouse pub is. Again, this is a small hill within the Lanes. This isn't as illogical as a place near Warnham in Sussex where you can find 'Knob Hill', which therefore translates as 'hill hill'. The village even has a 'Knob Cottage'. According to *Castles in Sussex* by John Guy, Knepp Castle has also been called 'Knob'. Not a name these days you'd want for an edifice designed to terrify others. Or perhaps it is. Knobs from Brighton have been selling well, due to local business, the Brighton Butter Company, which makes hand-churned KNOB butter using Sussex cows. The company aims to support the local dairy industry – so you could say it is a product with knobs on?

Kroto, Harry

Scientist Harry Kroto at Sussex University, along with his US collaborators, is responsible for the discovery that carbon can exist as tiny spherical molecules, now known as 'fullerenes' or 'buckyballs'.

L

Lanes/North Laine

Even established Brightonians get the Lanes and North Laine mixed up, which is to be expected, considering the similar spelling. Laines were the fields Brighton is built on and there are five of them when you add East Laine, West Laine, Hilly Laine and Little Laine. The word is an old Anglo-Saxon one meaning 'loan'. There is no South Laine – it is *the* Lanes, which is the Old Town. The Lanes are something completely different; there is only one and it is still mostly laid out in the same medieval pattern of the town that existed there until 1514 when burnt down by the French. The town was rebuilt on that same pattern, and even on the medieval foundations, so it is likely some of the oldest bits of Brighton are the cellars and basements of the Lanes. It was said that the town even went lower than that – the buildings were huddled together to protect from the elements and generally lower than the cliffs they were built on. 'North Laine' as a term was brought back into usage by Brighton's heroic planning officer, Ken Fines (1923–2008), and only became used again as a term when the North Laine conservation area was created in the 1970s. This was after the area (that had been threatened with the demolition of much of this wonderful historic area of Brighton so that a dual carriageway could be built on a flyover from Preston Circus to a car park in Church Street) became protected rather than demolished and Brighton adopted a culture of saving its historic buildings, which it has kept ever since. Lanes and Laines may be confusing, but we only have one of our Laines, North Laine, due to Ken Fines and we should salute his memory.

Level, The

Sussex has a rich history of cricket and the similar game of bat and trap. Brighton was once the home of the royal cricket pitch (today the Level) and Broadhalfpenny Down above Hambledon also has a Bat & Ball pub, just like the Level, which begs the question of why the Level is not a memorial to this hugely important royal cricket pitch that did so much to help develop the popularity of cricket? And why don't we still play cricket there, either? Brightonians still did as recently as the 1930s.

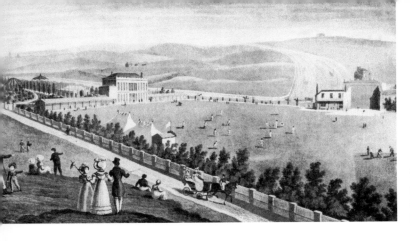

The Level and the site of Park Crescent today, once an important site for cricket in Brighton.

Lord of the Manor

Edward the Confessor, Henry VIII, Thomas Cromwell, Anne of Cleves and Secretary Jackie Aistrop all have one thing in common. Two of them might have been not the best of husbands, but Jackie's claim to fame back in 1988 wasn't that. They had all at some point owned the title 'Lord of the Manor of Brighton'. The lucky lady won the title of Lord of the Manor of Brighton in a competition organised by the *Evening Standard* newspaper. Jackie had one small problem, though: she lived in a flat 50 miles away in London. To further reduce the glamour of the prize, she was only allowed to use the title on her stationery, passport and coat of arms. Like most fifty-two-year-old secretaries, she unsurprisingly didn't have a coat of arms! The most famous holder of this title must be ex-boxer Chris Eubank, who purchased the Lordship of the Manor of Brighton in 1996 and at the same time acquired feudal rights to 4,000 herring and three cows a year – plus one slave. Quite who the slave was or how he would acquire the herring was never made clear.

Lost Locations

Brighton lost its original South Street when it was washed away by the sea. There is also a hidden road that you can see under Brighton station. Promenade Grove in Brighton was a public pleasure gardens that is now occupied by New Road, the Dome and the Corn Exchange since 1805. It opened in 1793 for only ten years. Brighton's German Place changed its name in 1914, as did most things in the county due to the hostility to that country during the First World War. Thankfully two German names – Sussex and 'Brighton' – were left alone, but even our royal family changed their German surname in the First World War. Much of Russell Street/Place is today under Churchill Square, a shame for the street that bore the name of the 'father of Brighton'. Chichester Place on the east side of the town on Marine Parade was originally 'Chichester Street' but its wealthy purchasers thought 'Street' too lowly a word to describe their superb street and so 'Place' was substituted. The most embarrassing name, had it not been changed to Spring Walk and today Church Street, would definitely be North Backside.

The coastline by the 1820s, showing where the beach and the lower settlement of Brighton had been before they disappeared.

The same coastline today. The construction of the King's Road has covered the site that the lower town once existed below but has left the Royal Albion (here to the right) less perilously close to the sea.

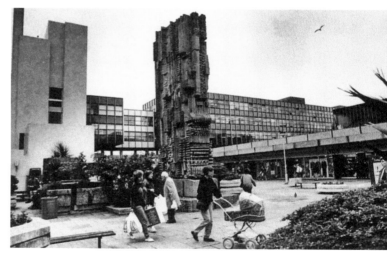

Churchill Square mark one – underneath which a hidden church lurked.

Sussex has lost a number of its churches, with the strangest perhaps being the Church of the Holy Resurrection in Russell Street, which was constructed on the orders of Brighton vicar Father Wagner, who built it completely underground in 1870. It opened in 1876 but only received worshippers until 1906 when it was closed and became a storage facility for meat and beer, to kept it cool in the days before refrigeration. When the first Churchill Square development was built in 1963, however, the building was emptied and is now nothing more than a few dark empty rooms beneath the outlets of today's second-generation Churchill Square.

Marina

Brighton Marina was only given permission to be built back in 1963 on condition that any buildings would never tower above the clifftops of Black Rock, obstructing the view of the flats and houses behind. This was not the first time a demand like this was made: the Aquarium (Brighton Sea Life Centre today) is built down underground as it was not allowed to be over the top of Brighton's East Cliffs either. Building eventually commenced in 1971 and today the Marina seems to have bypassed its legal requirement, as shown by the new developments being twenty-eight storeys high, and the biggest tower due to be forty storeys high.

Below left: One of the cranes building Brighton Marina's interior in the early 1970s.

Below right: An even bigger crane was needed to ensure the concrete caissons of the marina's external arm were correctly in place.

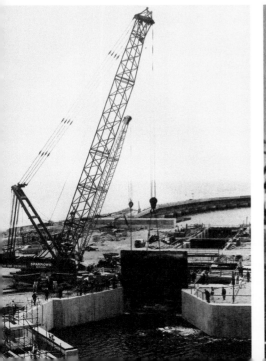

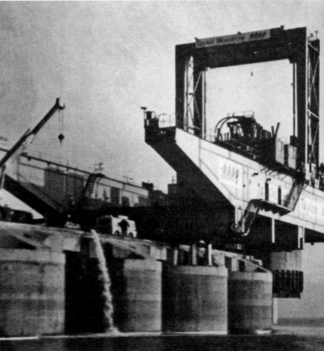

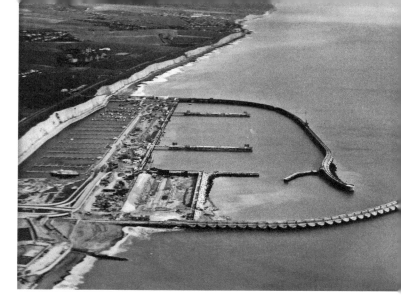

Right: The early and empty marina in the late 1970s.

Below: The marina today.

Metropole

It is hard to understand today just how prestigious and glamourous the international chain of original Metropole hotels were when first built. Starting in Cannes and Monte Carlo, they were the playpens of the billionaires of their day, a retreat for royalty and an escape for the most exclusive of clientele. Brighton being selected for the third of these massive palaces demonstrated the international reputation of the report and a reminder its origins as a desirable seaside resort patronised by kings and queens. It was, therefore, very fitting that the most prolific, high-profile and accomplished (not to mention profitable) architect of the late Victorian age was chosen to build this 'monster hotel'. Alfred Waterhouse, who could boast the Natural History Museum and Manchester Town Hall among his huge portfolio, gave Brighton and Hove not

As this advert from 1907 shows, the Brighton Metropole shared its name with fellow Gordon hotels in Cannes and Monte Carlo.

one but three buildings, two of which (Hove Town Hall and the Prudential Building in North Street) are no longer with us.

This was his only waterside building of any prominence and no expense was spared to make the building the most technological and luxurious it could be. The décor was lavish and extravagant, with even the letters 'HM' in gold leaf adorning the hotel's chairs. The letters can still be found in the (once heated) interior marble staircase and in the building's brick and terracotta exterior.

Despite facing an uncertain future by the late 1950s, it was rejuvenated in the 1960s to become internationally renowned once again, and its owners since the 1970s have continued to invest in and improve this Victorian masterpiece. Its current owners, the Hilton Group, take huge pride in their Victorian building and its literary, royal, social and historic heritage, as well as the fact that it is now Brighton's biggest residential exhibition centre. The building has expanded so that its footprint is over double the hotel's original size and enjoys a vital role in the conferences that visit Brighton, with prime ministers and leaders of the opposition still gracing its revolving doors. It has a number of mysteries, secrets and stories, including even a 'secret floor', which my Amberley book *Secret Brighton* provides more information about. With numerous awards won and further renovations and innovations planned, the future looks bright for this unique building, which has a bright future as well as a fascinating past.

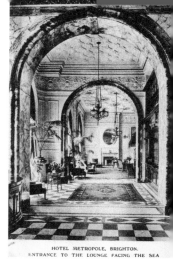

HOTEL METROPOLE, BRIGHTON.
ENTRANCE TO THE LOUNGE FACING THE SEA

Above left: The Prudential, North Street, Waterhouse's other Brighton building.

Above right: The Metropole's entrance lobby in 1890.

The lobby's much lower ceiling today, hiding the hotel's 'hidden' floor.

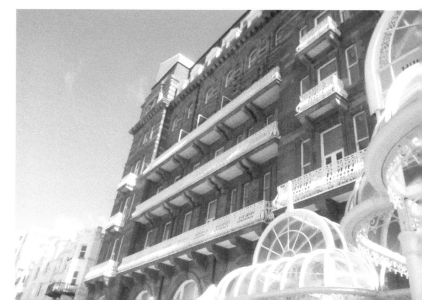

The Metropole today – Waterhouse's waterside wonder and his only remaining building in Brighton and Hove.

Musicians

In Brighton we have a strong tradition of hosting and being the home to great musicians, and Chesney Hawkes. The sadly defunct Hippodrome in Brighton hosted the Rolling Stones and the Beatles, which is reason alone for current restoration plans. On 21 August 1962 Brighton hosted the first ever 'Disc Festival' – as played by 'Disc Jockeys' – in other words, a records and music fair at the Metropole. In the 1970s, Sussex was home to 'Phun City', the UK's first large-scale free music festival, and at the Dome hosted the 1974 Eurovision Song Contest, which propelled ABBA to worldwide fame. Major festivals include the Great Escape Festival and Glyndebourne Festival Opera. Brighton has produced or has links with numerous artists from the Levellers to Royal Blood. Kylie played her first live performance in Britain at the Metropole in the 1980s, Fat Boy Slim is almost Brighton royalty and James Bay was a student here at the British and Irish Modern Music Institute. Even David Bowie played here.

The Brighton Centre, Brighton's biggest music venue.

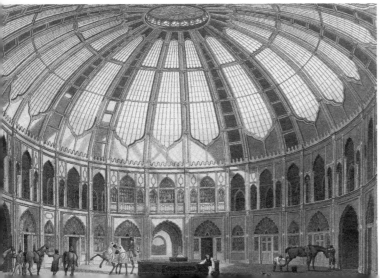

The Dome in its original guise as George IV's stables and riding centre.

The Dome in 1974 as a concert venue – here hosting that year's Eurovision Song Contest, which ABBA won.

Mastermind behind the musical hall of fame (between Concorde 2 and the Palace Pier), David Courtney said that 'Brighton is a pioneering place for so many things, but it's always been a hotbed of music.' Courtney would know as he worked with Shoreham superstar Leo Sayer back in the 1970s and said: 'Outside London you would be hard-pressed to find somewhere with so many names attached to it.' Lastly, Chesney Hawkes once performed his hit 'The One and Only' at the Odeon in Brighton in the 1990s to at least a dozen screaming teenage girls.

Below left: Bowie, who played a gig at Brighton.

Below right: The Concorde 2, famous Brighton music venue and home to a hidden lift.

Names

One of the characters you could find at Hove's County Cricket Ground in the 1920s was an old man nicknamed Cushions who made his living hiring out cushions at 3*d* a time to make your match more comfortable. The ground had hard wooden benches at this time so he was no doubt a successful elderly entrepreneur. The first person to entertain the thought of educating poor children in Hove was the wonderfully alliteratively named Revd R. Rooper back in 1840. Another Hove school was run by the sweetly named Miss Hoggi. A much less pleasant name was back in the 1800s, when Brighton had a leading policeman who might not have been too gentle if his treatment of criminals was anything like his surname, which was Chief Constable D'eath. Luckily at another point in Brighton's history, Brighton's Chief Constable was

Brighton Town Hall, early home to the town's police station.

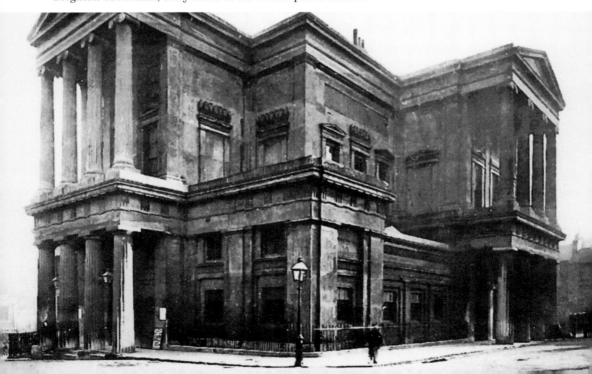

called William B. Gentle. Presumably he was much nicer in his treatment of Brighton's criminal world! Two Brighton and Hove teachers in the twentieth century also had names that might have given them some grief: a Mr Bender and Mr Willy. Should you walk through the New England Quarter in Brighton, there is a street named after Frederick Lanchester, one of Britain's earliest car designers and makers. Lanchester was brought up in Brighton and his name is synonymous with early great British cars. He is also known for his role in developing aircraft built in Middleton, near Bognor, during the First World War.

Numbers

If you like numbers, then try these for size: Brighton has been habited since 3000 BC and has an estimated 100 billion pebbles on its beach, all along 5.4 miles of coastline. We have 13,600 miles of sewers, whereas only 8,070 miles of water mains. Perhaps this means we produce a lot more human waste than we drink or wash? We have over 10,000 acres of council-owned farm and farmlands, ninety-eight parks and public open spaces, and if the countryside isn't for you, then why not drive continuously along one of our 3,000 plus roads.

Old Ship Hotel

The cellars under the Old Ship Hotel are the place for a private dining experience that takes you back to the earliest days of Brighthelmstone. The hotel, Brighton's oldest, started life originally in the 1500s back in Ship Street, not on King's Road. The cellars are built with stone from Normandy, suggesting they have been lined with stones from the walls of Brighton's monastery, which the French destroyed in 1514. The Old Ship also has a Tudor room that was originally Brighton's post office until 1777. More recently, the Old Ship's cellars are also where Churchill was said to have held a wartime cabinet, wisely for the great wartime leader would never have been far away from food.

Churchill was notoriously demanding in his requests when staying in Brighton hotels (only the cream from the milk to make his porridge was one example). This was nothing compared to one experience by staff at the Old Ship a decade before Churchill's visit. One 1930s guest, who had been celebrating at the hotel, was shown up to what the porter believed was his room, as the guest was presumably too tipsy to remember his correct room number. On the bed was laid out a lady's dainty lace nightdress. Taking out his monocle, the guest surveyed the dress, sniffed it and

The Old Ship's exterior today.

The Old Ship's delightful Paganini Ballroom, which recently celebrated its 250th anniversary.

The fish and chip shop near to the Old Ship that a Labour Party grandee stormed out to in 1981.

asked the porter: 'What is this?' 'It's a lady's dress', the porter replied. 'Take it away', the guest ordered, 'and fill it!'

The Old Ship hasn't just hosted guests of a Conservative persuasion. At the 1981 Labour Party Conference in Brighton Labour titans Tony Benn and Dennis Healey were staying at the Old Ship and were battling it out for the post of deputy leader of the Labour Party and Benn lost. Healey offered him a drink to commiserate but Benn apparently stormed out and had tea at the nearby fish and chip shop. His defeat must have made him hungry though, as he returned to the hotel for his supper.

Opening Ceremonies

The i360 and Brighton's Palace Pier formally opened to the public in 1901 and 2016 – over a century apart. Both faced storms on their opening days that affected the celebrations. They both weren't strictly finished either – although it partly opened in 1899, the Palace Pier's seahead section didn't open until 1901 and the i360 also had its surrounding buildings and landscape not completed. It wasn't just stationary buildings

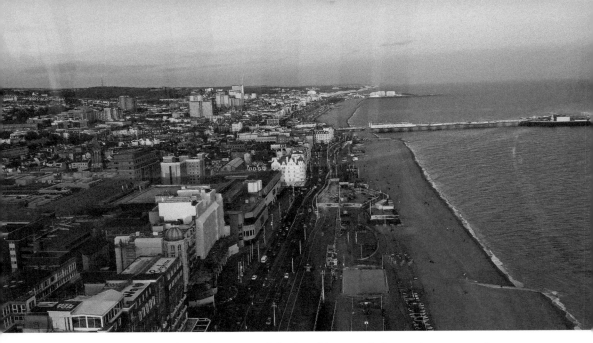

The Palace Pier viewed from the i36o. Both had problems at their opening ceremonies.

that had problems either in Brighton: its different railways had awkward openings. In 1840 embarrassment followed when the first line to Brighton to Shoreham's opening ceremony was delayed due to the breaks of one of the new carriages being left on. Brighton's electric Volks' Railway also suffered humiliation on its opening run in 1883 when the combined weight of the corpulent aldermen assembled in the railway carriage proved too much for the then futuristic method of transport.

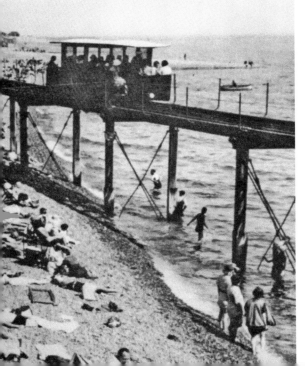

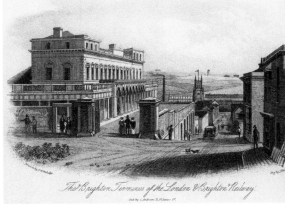

The Brighton Terminus of the London & Brighton Railway.

Above: Brighton station. The line to here from Shoreham also had problems on its opening day.

Left: Volk's Railway, which also had opening day embarrassments involving overweight aldermen.

P

Paint

The Duke of York's cinema in Brighton was once blue, as was the Royal Pavilion until the 1970s. The Old Ship Hotel went one step further and was once a patriotic mix of red, white and blue. Brunswick Terrace and other regal housing developments once used to have rustic green windows and doors, aiming to make their residents used to rural life feel somewhat closer to the countryside. Brighton has a history of film, photos and filming, with numerous films made in the town and early photography shops opening from the 1840s. The town's first photographic studio was in Marine Parade, opening in 1841. Its opening day was graced by none other than the world-renowned painter William Constable, who famously painted Brighton's Chain Pier. Brighton even had one of the country's first women photographers: Agnes Ruge, who had a daguerreotype business based in Western Road. Communism caused her to come together with her husband – he had fled the continent with Karl Marx, whom he was an associate of and so was in

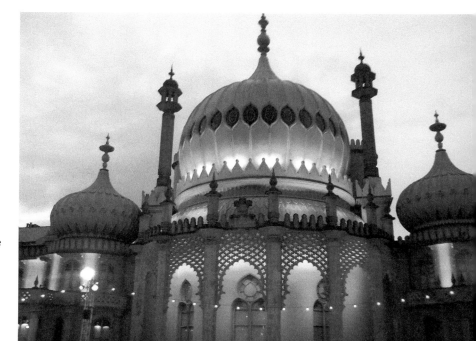

The Royal Pavilion, here coloured by lights, not paint.

the UK in exile due to his political beliefs. It wasn't just photographs of Brighton that were popular at this time either, as there were more Victorian engravings made of Brighton & Hove than of any other town or city in the UK outside London.

Peace Statue

Sussex has statues that seem to be linked with pain, death and destruction. Brighton and Hove's peace statue wasn't much of a good luck charm for peace as war broke out two years after its unveiling. It was built to honour Edward VII 'the peacemaker', who had done much to bring a peaceful alliance between Britain and its old enemy, France. Its opening ceremony didn't bring much peace either to PC Ellis, one of the police escort who was on horseback. His horse collapsed during the march past and ended up crushing his leg.

Piers, Plays, Privates and Pooches

In August 1894, the Brighton Dog Show on the Palace Pier was the first ever dog show ever to take place on a pier. Not only dogs were exhibited from the pier either. Until the 1930s specified clothing rules were administered on the pier's deck, but male bathers were allowed to swim in the nude with their privates out from the pier until 9 a.m. Another private who paraded his talents on a Sussex pier was Private Godfrey from *Dad's Army*, in real life the actor Arnold Ridley. Ridley, long before his *Dad's Army* fame, wrote a play called *Ghost Train*, which was performed at the West Pier's theatre in 1927 as part of a run of shows on Britain's piers. Asses were also on view by the Chain Pier, but of the donkey kind. They were used in the pier's early days to work a treadmill that brought seawater up in buckets to clean the streets nearby. The city has reused or recycled a number of different aspects over the years.

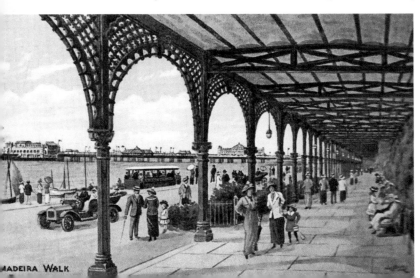

Madeira Walk with the Palace Pier in the background during the era when nude swimming was allowed from the pier.

MADEIRA WALK

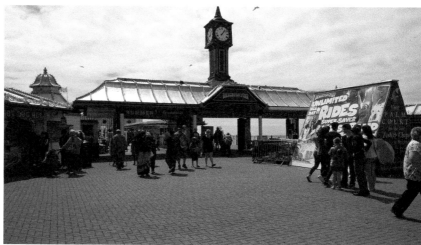

Above and right: The Palace Pier today.

The Palace Pier is an unusual epicentre of recycling in Britain. The Palace Pier also gave old metal girders to be recycled into tanks and aircraft during the Second World War to help with the war effort.

Brighton's earliest pier also had a huge impact on the town. The Chain Pier, destroyed by a storm in 1896, was technically a suspension pier, with chains suspended from pylons. The style of the pylons was inspired by ancient Egypt, and these pylons themselves then went on to inspire the doorways of the Pentecostal Church in the Lanes (the Font pub today).

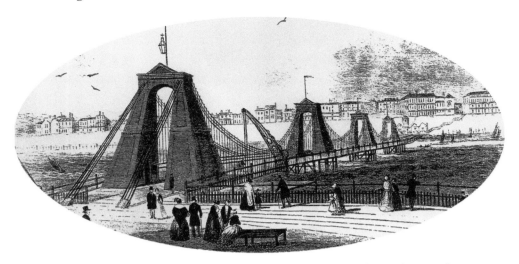

The Chain Pier, which has left its impact on Brighton today despite being destroyed in 1896.

Ping, Nimrod

The late Sir Terry Wogan used a variety of methods to make his listeners to his radio shows laugh, such as his Janet and John stories. One ongoing joke was measuring how unusual people's names were, using Brighton Councillor Nimrod Ping as the benchmark. Nimrod was not only memorable because of his surname, but because of all the good things he did for his adopted home town. Originally hailing from London, he was an architect and town planner who built the award-winning Lewes Road Sainsbury's (although he made sure people knew the adjacent Vogue gyratory was nothing to do with him, understandably). He saved Punch and Judy shows on Brighton seafront and pushed for the first nightclubs to open there too. Brighton's Pride Festival grew due to his work and support, and he was one of Brighton's first openly gay councillors. Even though he sadly died in 2006 of an illness linked to hepatitis C, when diagnosed with it he helped publicise the condition and helped others who had to live with the illness. Even his funeral was a suitably memorable affair, with mourners told not to mourn but to wear bright colours, which his brother Peter Ping did, gracing the occasion with yellow trousers, bright green hair and a colourful orange jacket. Should Brighton ever have a city anthem, at least one verse should be sung about this colourful councillor, who had two business cards, one of which read 'architect, town planner and troublemaker'.

Police and Politics

Brighton and Hove got its first female police officers in 1918 but it was not until 1942, unfortunately, that the rest of East Sussex would gain their first female police

Chief Constable Henry Soloman, who was murdered by a suspect. (Courtesy of Royal Pavilion and Museums, Brighton and Hove)

constable. Perhaps they should have done the same as Miss Mary Hare, who, in 1915, set up her own womens' police force against the wishes of the local constabulary. Brighton was, of course, part of East Sussex back then and incredibly today, women were first allowed onto the county council from 1919 but were advised 'not to speak for the first six months'. At least the earliest female police officers and councillors had it easier than one of Brighton's earliest police chiefs. Brighton is the only place in the UK where a serving Chief Constable was murdered in office – Henry Solomon in 1844. The police station was where the Old Police Cells Museum is now sited. It's strange to think that back then Brighton's police station would have been so quiet that one man was left alone to guard a prisoner in those days. It is certainly a huge contrast to Brighton police station today, which is the second busiest in the country.

Portslade

Portslade has some hidden gems. The oldest part of the village still has the ruins of a twelfth-century manor house, next to St Nicholas's Church, in the grounds of the old convent, north of the Old Shoreham Road. Medieval manor houses are a rarity so Portslade's ruins are to be cherished. Heading south, St Peter's School, near the coast of Portslade, has the most amazing set of Second World War air-raid shelters, which the school opens up once a year to visitors at their school fair. The huge set of tunnels were originally believed to be a waterworks development but were converted just before the war and could fit up to 2,000 people when the port took a pounding during the war. The suburb of Brighton and Hove also was prepared for the subsequent Cold War. It boasts one of only six nuclear decontamination centres in the UK at the back of the old police station in St Andrew's Road.

Above left: The twelfth-century ruins of Portslade Manor House .

Above right: One of the tunnels underneath St Peter's primary school in Portslade that were used as air-raid shelters during the Second World War. The school gives tours of this remarkable wartime construction.

Below: The exterior of Portslade's old police station, which hides around its southern side.

A rare Cold War era nuclear decontamination centre – one of only six in the UK.

Previous Pupils

Hove has had a huge range of famous people schooled in its streets. In 1841 it had ten schools and this increased to a peak of thirty-eight in 1871 – remarkable for a small town. Its beneficial climate, sea air, good drainage and 'perfect sanitary arrangements' were used as factors to get a range of children to the town, including none other than Winston Churchill, whose heath improved dramatically here once he'd recovered from a serious bout of the flu at first. Having the family doctor at his bedside (who lived in the town) must have helped when he was sent here as a sickly little boy to be schooled between 1883 and 1885. Exemplary engineer Isambard Kingdom Brunel was schooled in Hove, along with author Patrick Hamilton, whose books on Brighton were saluted by Graham Greene. Both Churchill and Brunel had scrapes with metal while they were here: Brunel swallowed a sovereign coin and had to be turned upside down to stop him choking to death, and Churchill had an argument with another pupil over a penknife and the future prime minister ended up being stabbed. Thankfully the blade only penetrated an inch and did no lasting damage. With his physician saving his life here, you could say that Churchill was both nearly killed and arguably saved from death by coming to Brighton and Hove.

Queens

Queens feature heavily in Brighton past and present – as you would expect. Starting with the small, the Queensbury Arms in Queensbury is the smallest pub in Brighton and was once called the 'Hole in the Wall'. The street is aptly named the Marquis of Queensbury, from who the 'Queensbury' boxing rules are named after, and arch-nemesis of Oscar Wilde used to sit in the smoking lounge of the next-door Metropole, smoking cigars. The street is also the home of Brighton's French Reform Church, one of only two in the country. It is now a private house.

The former French Reform Church, one of only two surviving in the country and today a private dwelling.

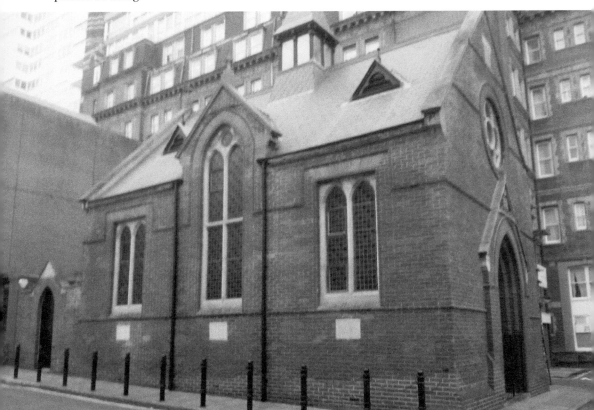

Q

Queen Victoria

Queen Victoria didn't visit the Royal Pavilion until four months after she became queen as her uncle, William IV, didn't get on well with Victoria's mother, the Duchess of Kent. She made up for her lack of visits with several in the early years of her reign, until she took a dislike to the lack of privacy and space the Pavilion had, along with what she deemed the intrusive nature of inquisitive and rude Brightonians. Her first visit to Brighton included a grand entrance through a specially created archway at the north end of the Pavilion and she also arrived via the Chain Pier on one occasion via steamship.

Another journey to a snowy Brighton gives us one of the most charming images we have of her and Albert on a sledge, and her other legacy was the sale of the Pavilion in 1850 to Brighton Corporation (now the council) for a knockdown £53,000. Today we have the Victoria Fountain in the Steine to remember her (it was built in honour of her birthday), her statue, pubs named after her in Portslade and Rottingdean, Victoria Avenue, Victoria Gardens, and Victoria's Jubilee Clock Tower at the top of West Street, but no hotel. Brighton Harbour Hotel at the bottom of West Street was once the Victoria Hotel but has been renamed several times since then. Perhaps the queen we should be most grateful to in Brighton is Queen Mary, wife of George V. Her rambling of the antique shops of the Lanes helped make the area desirable again and she even explored George IV's tunnel from the Pavilion to the Dome in the 1930s.

Queen Victoria arriving at the Chain Pier in Brighton via steamship. (Courtesy of Royal Pavilion and Museum, Brighton and Hove)

Victoria's fountain in the Old Steine, built by Amon Henry Wilds for Victoria's twenty-sixth birthday.

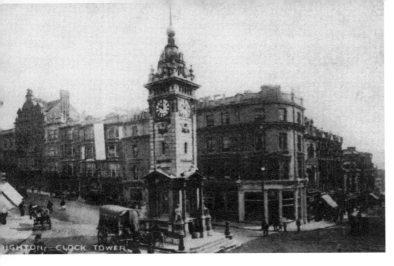

The clock tower, built to celebrate Victoria's jubilee in 1887, opened a year late in 1888.

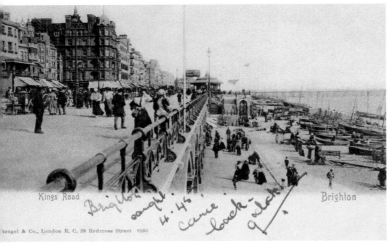

Brighton Harbour Hotel, when it was the Victoria Hotel with its original red-brick and terracotta exterior. Note how nice the buildings were that the adjacent Kingswest Boulevard replaced.

Above left: The Victoria Hotel at the bottom of West Street just before its latest rebranding as the Brighton Harbour Hotel. The red exterior is now covered over with paint.

Above right: The Lanes in the 1960s.

R

Royal Albion Hotel/Dr Richard Russell

The 1826 hotel was built on the site of Dr Richard Russell's surgery, which had existed on the site in the 1700s. Dr Richard Russell was the doctor who brought large numbers of the first wealthy visitors to Brighton to undergo his seawater treatments following the publication of his book called *De Tabe Glandulari* – (for short). It recommended bathing in (and even drinking) seawater as a cure for many diseases. Woodlice, crabs' eyes, burnt sponge, cuttlefish bones and vipers' flesh. Mice were also, believe it or not, used here as remedies in the days before pharmacies. It was recommended that you roasted and ate them or crumbled them into a drink. This usage led to the mishearing by one Portslade mother, whose doctor had told her to put some ice in a bag and then hold it on the head of her poorly son, Tommy, to treat a malady. When the good doctor enquired a day later how Tommy was doing, his mum replied that he was feeling much better. 'But Doctor', she said, 'I'm sorry to say the mice in the bag all died.'

George IV endured Russell's treatments and was a big fan of the good doctor, but Russell's father-in law William Kempe hated him. Russell had to marry Kempe's beloved daughter away from the family church, so much did Kempe disapprove. Even though Russell travelled abroad to study at the best medical university of its day, and would go on to be surgeon to royalty, Kempe never liked him due to religious differences between

Dr Richard Russell, the most successful advocate of seawater cures and 'father' of resort era Brighton.

The Royal Albion Hotel today, built in 1826 on the site of Russell's surgery and hydro. Compare the hotel with its earlier years and the distance of the hotel from the sea in the earliest pictures.

the two. Russell was not allowed to touch the Kempe fortune and estate while alive. Kempe even continued his spiteful treatment to Russell after his death. Russell's son was ordered in Kempe's will to change his name to Kempe if he wanted to inherit and Russell's surname was not even allowed to be used by future generations of Kempes as a Christian name. Perhaps a good seaside swim might have cheered Kempe up?

The *Daily Mail*'s front page in 1906 failed to cheer one of the town's leading lights up. It featured a story slating Brighton as an outdated and unattractive holiday resort. The town's hotel impresario, and owner of the Royal Albion and Royal York hotels, Sir Harry Preston took himself up to the paper's offices and the following day the *Mail* not only retracted its article but also published a much more complimentary feature about the seaside town. Preston's love for the town he defended is shown by the way he took unprofitable hotels in Brighton and saved them from probable demolition in the 1910s. He bought and renovated the Royal Albion, which had been closed for thirteen years from 1900, and made it and the Royal York into two of the town's most fashionable hotels once again.

Russell's earlier house and surgery was one of the first houses rented out to visitors and without this building, Brighton might not have attracted royals including the uncle of the Prince Regent who first invited the future George IV to Brighton. The Albion Hotel, as it was originally known (the Royal was added later in 1847), replacing Russell's house, opened its doors on 27 July 1826. Built by Brighton's most prolific architect, Amon Henry Wilds, it is a fantastic example of a Regency-style building. It had a wide range of royal visitors in its early days. It has also survived the 'seventy-year itch' that Brighton's hotels seem to suffer from. The Royal Albion also survived a horrific fire in the 1998 and is now one of the many hotels that enjoys the trade from conferences, being fully booked, as are most hotels at the time of political party conferences.

Royal (Marine) Pavilion

Brighton's Royal Pavilion wasn't the first Indian-inspired building in Britain. Sezincote in the Cotswolds and Daylesford House in Gloucestershire both have Indianesque elements, but of course nowhere near as dramatic as the prince's palace. George was inspired to redesign his Marine Pavilion into the Indianesque Royal Pavilion after the success of his stables, which are the Dome, Corn Exchange and Brighton Museum today. They were designed in the Indianesque style by 1805, whereas the Pavilion was only finished by 1822. By this time George was not able to properly enjoy his creation and only visited a few times after this, his last being in 1827. His palace went on to inspire both the West Pier and Palace Pier though, with both having palace-style buildings at their sea ends originally, and the Palace Pier paying homage to the Pavilion through its name. The Pavilion didn't inspire a glut of Indian-style buildings across the land, but Brighton's most prolific architect, Amon Henry Wilds, built his own home, the Western Pavilion, in the same style. It is near to Waitrose today, tucked down Western Terrace off Western Road.

The Pavilion is Brighton's most famous building, but that doesn't stop it having several mysteries we don't know the answers to. There are places where nothing exists within the building, presumably leftover spaces from when Prince George ordered the removal of the east wings during one of its makeovers. We still don't know where the prince's Chinese lantern room was, and the building today is only a part of its total size at its biggest – much of the southern rooms and kitchens were demolished. Two buildings, one of which was Brighton's huge Castle Inn, were demolished to allow it to expand but at its heart is still a lowly Brighton farmhouse. The staircases were constructed of fake bamboo as George thought metal handrails too cold, and even the metal supporting pillars in the kitchen were disguised as palm trees to add to the warmer-climates feel of the palace. George hated the cold and the palace was always kept unbearably hot, with servants keeping the furnaces going and small boys forced to climb up 9-inch-wide chimneys in scary conditions to clean the chimneys. The Pavilion was a place of pain, as well as pleasure. Most mysterious are four holes in the kitchen. The Pavilion's kitchen was steam powered and it is believed these holes contained steam pipes to heat hotplates or other paraphernalia.

Army markings on several floorstones in the Pavilion's kitchen suggest Prince George (or one of his staff) might have done a deal with the military who were guarding him from the barracks nearby to craftily gain some supplies meant for army building within the town. George wouldn't have been the only one 'Doing a Del Boy' if that was the case in the Pavilion. His head chef would sell off his exquisite dishes meant for the prince and his guests to locals from the side door of the Pavilion (particularly pate apparently) and pocket the proceedings. The problem with that? Staff were meant to share any ill-gotten gains among themselves.

Saint Nicholas's Church

It is easy to forget that Church Street is so-called as it leads up to Brighton's oldest church, and its oldest building: St Nicholas's. The church also had a vital function for several centuries as a navigational beacon for sailors at sea approaching the town. It may have helped back then, but it confuses us today with two of Brighton's mysteries. The first is why was the town's church away from the town, up on a hill, especially when St Nicholas is linked to the sea, and therefore to the fishing town below in the valley? Its lofty location might suggest it had a role in the plague of the 1340s in keeping plague graves away from the town or perhaps there was an older Brighton community around St Nicholas's? However, no evidence has ever been found to suggest either. The second mystery is why the Domesday Book of

In this 1760s image of Brighton we see Church Street to the right of the picture, sweeping up the hill to the town's parish church, still at this time separated from the town. (Courtesy of Royal Pavilion and Museums, Brighton and Hove)

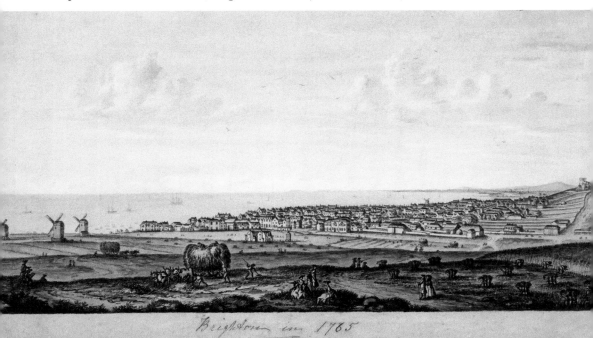

Brighton in 1765

1086 records Brighton as having a church but there is no evidence that St Nicholas's is that church? Where was Brighton's earliest church if not there? Even more mysteriously, St Nicholas's has a decorated font, which dates from 1160 to 1170, but why is an interior part of the church is older than the exterior? Could this font, the oldest physical part of Brighton, be from the older church? It is believed some of the stones of St Nicholas's were from the earlier church.

South Street

Brighton has a long-lost street. The original South Street existed, unsurprisingly, to the south of the town. When it was washed away in the 1700s the town just stopped at the cliff edge and travellers had to travel up inland through the Lanes until the King's Road was built on George IV's orders. This meant that today we still have a major East, West and North Street but no major South Street. The first three were once the boundaries of the old town and beyond this were mostly fields until the 1700s. This is probably why Charles II was thought more likely to have stayed at the George Inn in West Street rather than Middle Street as some historians think when on the run during the Civil War in 1651. West Street would be easier to escape from if Cromwell's forces caught up with him. Brighton does have a small South Street today but it was renamed to become this. In the same storm, the 'Lower Town' where the fishermen lived was also finally washed away, which sped up the erosion of Brighton's old town below the cliffs. The only picture we have of this town on the beach is the very first picture of Brighton, said to be of 1545 but actually around 1514. Many men lost their lives on that night and two windmills were blown over in the town. Due to storms in the 1700s, Brighton also had a lost sea wall, similar to the one at Hastings, which still exists today. It was built as a deterrent to further French invasions after the attacks in the 1500s, but was also destroyed by the storm of 1703. It is worth looking at the black huts on Hastings seafront to get an idea of what 'South Brighthelmstone' was like. Not to say Hastings is stuck in the past.

Sheena

The powers that be who had booked the Metropole for the Ford Motor Company's annual salesman's conference had decided back in 1962 that the year's top salesman would win a holiday to Morocco. It was asked what summed up the north African country to give the conference a Moroccan theme and the reply was 'a camel'. So, a local zoo was contacted and, lo and behold, Sheena the camel was transported down to the Metropole to tour through the newly built conference suites in the build up to the great prize announcement. A holiday to Morocco was exclusive beyond belief in the 1060s and tensions were high. Nobody had noticed that the only tension was on Sheena's bladder

and the only thing building up was the urine that she needed to relieve. As soon as she entered the Metropole's recently refurbished lobby the camel started to spray wee at a fast velocity. Faster than the speediest Ford of the day, a quick-thinking Metropole manager grabbed a bucket and managed to catch every drop.

Steine, The Old

Brighton's Steine today has a wonderful war memorial, fantastic fountain, lawns and a café but is surrounded so much by constant traffic that we forget its earlier uses. Originally a swampy ground covered in stones, used by the town's fishermen to dry their nets, this is where it gets its name. It was also a river valley for both rivers that ran down the Lewes and London Road valleys, draining out into the sea in a small harbour, with water collecting also in a pool that gave Pool Valley its name. When royalty and the aristocracy first visited the town, it was the Steine that was the first and foremost place to be seen – its houses faced inwards as this was where the aristocratic action of the day took place. George IV's first version of the Pavilion even had mirrors

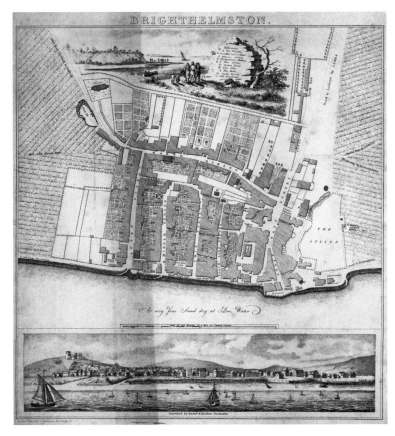

This 1770s map shows the Steine before much development had taken place east of it.

so that he could watch those parading around the fashionable walking ground from his bedroom. It also became something of a place of entertainment – George and his chums held shooting events in the Steine, resulting in the destruction of several chimneys. Some bullet marks are still said to be there today. Before Brighton turned its back on the Steine and started looking seaward for its most fashionable walks, it was also a place of high jinks, competitions and entertainment. Aristocrats would ride bullocks and piggyback each other in competition against senior citizens in their eighties. Perhaps if Brighton ever hosts the Olympics or the Commonwealth games ...

Stoolball

The Sussex game of stoolball was chosen in 1917 to be the feature of the wartime-requisitioned County Cricket Ground in Hove. The two teams consisted of a team of elderly lawyers 'damaged by age' and injured soldiers staying at the Royal Pavilion who were 'damaged by wounds'. Despite the wounded servicemen's team each having one arm missing each, they still managed to be the elderly legal eagles. The Second World War witnessed a wonderful match between the Royal Australian Airforce servicemen based at the Brighton's Metropole Hotel and local auxiliary firemen in a Brighton park. Despite only managing to recruit around a hundred spectators, the match was a lively one, with the firemen captained by local Sussex wicketkeeper 'Tich' Cornford and Aussie Flight Sergeant Keith Miller hitting a six that shattered the park's cricket pavilion clock.

Signs and Symbols

There are many hidden types of symbols hidden across Sussex that provide us with clues as to a building's designer or prior use. The first is the motif of Amon Henry Wilds, the junior 'partner' in the triumvirate of architects comprising him, his father Amon Wilds and Charles Augustin Busby. Amon Jr decided to play on his name by decorating his buildings in Brighton with *ammon*ite shells and today many of these still exist – in the Steine, London Road and even on his father's grave at St Nicholas's. High up on top of the Metropole in the hotel's rooftop function room, hidden deep behind later redecoration, are a number of stars that once decorated the room. This is as the room was once a nationally renowned restaurant, called the Starlit Room. Today called the Chartwell Suite, when the room was a hangout for royalty and VIPs it was decorated throughout with stars, hence the name. Stars and celestial navigation aids even decorated the glass of these rooms, which were the UK's first ever rooftop restaurant. The Metropole still owns some of the metal decorative stars but the most are now covered up. The idea was also that romantic couples would, with the clear glass panels of the restaurant, have romantic meals lit by the stars.

Tattersell, Nicholas

A very cheeky Brightonian was our 'mayor' in the 1600s: Nicholas Tattersell. As mentioned earlier, he helped King Charles II safely escape to France in the Civil War, but he was determined that the one-time fugitive king should remember just who had done it. He was not only paid £200 (a fortune then) by Charles for the voyage, but also another large sum when Charles was crowned Charles II in 1660. Tattersell put just a bit of pressure on the new king to get this, sailing his vessel up the Thames to remind Charles just who had saved him. Tattersell bought the Ship Inn in Ship Street with his new fortune and his vessel was commissioned into the Royal Navy, becoming the *Royal Escape*. Tattersell was made a naval captain for a while but it seems he was so arrogant that he was dismissed and returned to Brighton, becoming High Constable (a bit like mayor today) and being generally unpleasant, persecuting Nonconformists and bossing townspeople about. His grave at St Nicholas's leaves us in no doubt just how much this arrogant man is owed by his nation from his one action in 1651 that saved a royal family. It's a shame he did it for money and not as a selfless or dutiful notion, otherwise he would be one of Brighton's great heroes. His ship certainly was a Brighton hero though; the *Surprise* lasted for at least 140 years – it was reconditioned by the navy and

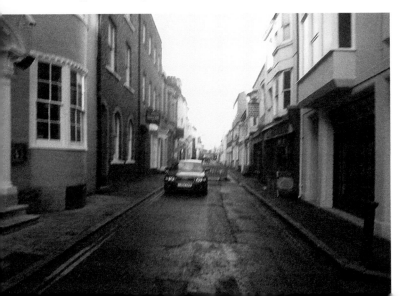

Ship Street showing the location of both the old and 'new' Ship taverns. The 'new' Ship is today the Hotel du Vin.

was still in service until 1791. An arch from this 'Old Ship' was in the stable yard of the Old Ship for many years and is now still in Brighton Museum. This was not how the Old Ship got its name though: its name changed from just the 'Ship' to distinguish it from another Ship Inn that bizarrely also opened in the street across from it. Quite why the owners of the new 'Ship' chose the same name is somewhat of a mystery but we do know the location today is where the Bar du Vin and Hotel du Vin are.

Twittens

Brighton is blessed with an historic wonderland of awesome alleyways with the Sussex name of 'twittens' (supposedly as they are 'betwixt and between') that makes the Lanes an atmospheric, bustling and sometimes spooky experience, depending on what time of day you walk down. Who needs Diagon Alley in Harry Potter when you have the Lanes? The twittens give the Lanes something of the shape of a chessboard pattern, or at least they did until the Victorians carved the curved Prince Albert Street through the roads. According to legend, the Lanes were the scene of King Charles II ordering the man carrying him to knock a fisherwoman to the ground on his escape from Parliament in 1651 so they could get past her. Brighton's twittens were not just the one-time routes of fisherfolk but also provided the location for one amazing bet lost by a friend of the future King George VI in 1790. The Barrymores were a wild family of Irish aristocrats and Lord Barrymore, an athletic member of the family, made the mistake of accepting his portly friend, Mr Bullock's bet that he could beat him in a 100-yard running race. Bullock's only terms were that he be given a 35 yard start and could choose the route. Barrymore acquiesced and allowed Bullock to choose the narrow Black Lion Lane twitten, which was too narrow for the Irish aristocrat to get past his portly pal. Who ever said larger people can't win running races? Like Worthing, Brighton's twittens were used by smugglers escaping from the law men and another, raunchier (fictional) breaking of the law was Phil Daniels and Leslie Ash's escapades in the twittens off East Street in the film *Quadrophenia*.

Black Lion Passage, one of Brighton's twittens that crosses the Lanes. It was the site of an unusual wager.

UFOs

The skies over Withdean were apparently the location for the sighting of a UFO in the 1950s. Sheila Burton, a resident of the affluent Brighton area, awoke early one morning in September 1951 at 6.30 a.m. to see a flashing object looming high in the sky, rapidly divebombing down towards her garden lawn. According to John Hanson, who recalled what Mrs Burton had witnessed in a letter to the *Argus* in 2008, the spacecraft then revealed panels that opened as it landed, from which three 5-foot-six-inch tall bald men exited and had 'bald heads, odd expressionless faces, small pointed noses and ears'. They lacked lips apparently but had 'deep set eyes and were dressed in khaki one-piece garments'. Despite carrying weapons of some sort, they thankfully didn't use them on Mrs Burton, Mr Hanson reported. After their close encounter the men decided to return to their spaceship, which was able to rocket vertically into the sky. UFOs have also been reported over Ditchling Road, Woodingdean, Hove Park and Shoreham over the years. Should extra-terrestrial life decide to make first contact with humans they couldn't choose a better city than Brighton. Brightonians have had centuries of welcoming new visitors, often from far away, and are known for tolerance, acceptance and hospitality. Plus, being Brighton, nobody would turn a blind eye.

Umbrella (the Chattri)

Valiant Sikh and Hindu Indian soldiers from the First World War who died of their injuries in the trenches were treated in Brighton hospitals and had their cremated ashes buried up on the Downs in an isolated spot north of Patcham at the Chattri Memorial. Meaning 'umbrella' in Hindi, Punjabi and Urdu, this memorial is well worth the walk from Braepool or the Jack and Jill windmills and provides an amazing view of Brighton. Today it is a registered war grave but was disrespectfully used for target practice in the Second World War. It can also be seen across the fields from the A27 as you drive downhill from the Devil's Dyke junction. The white cupola on top of a white set of steps and platform is now officially looked after by the Commonwealth

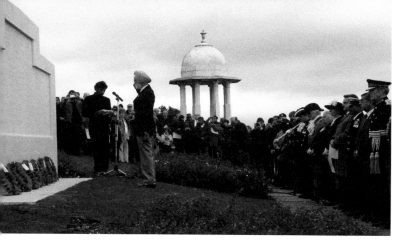

Above left: The Chattri's annual memorial service by the city's Anglo-Indian community.

Above right: The Chattri, a worthwhile destination for a thoughtful Downland walk.

War Graves Commission. It lists all the names of the soldiers who were cremated and is a poignant reminder of the sacrifice made by the 1 million Indian soldiers who fought for the British Empire against the Kaiser's Germany in the First World War. It was unveiled in 1921 and every year a memorial service is held there to remember these gallant soldiers who fought for a far-away country. It is somewhere everyone in Sussex should visit at some point in their life.

Universities

There are two universities in Brighton but there are a number of other higher and further educational establishments across the county, meaning a number of worthies, celebrities and famous people have spent their time studying here. Matthew Dent designed current images on our coins so you carry his work around with you. Brighton University was the home to Andrew Goodall, Chief Executive of Brighton Marina, and John Pasche, who designed the tongue and lips logo for the Rolling Stones. The university has championed musical talent as well, with Natasha Khan (Bat For Lashes) and Orlando Weeks from the Maccabees attending. Billy Idol started his secondary schooling at Worthing High and ended up at Sussex Univeristy, as did Labour grandee Hilary Benn. On the topic of politics, Guy Scott, the temporary Prime Minister of Ghana, studied here in Sussex, as did comedian Frankie Boyle. Bob Mortimer studied here in his days before teaming up with Vic Reeves and Fat Boy Slim. Norman Cook was right here at university then too. Radio 2's Jo Whiley also spent here university days here, studying Applied Language. Put them all together and it would have made an interesting Student Union bar. If Sussex University isn't magical enough for you, then you can always join Harry Potter fans studying at Sussex University today, who bring the boy wizard into the present day and keep him alive when you join the Sussex University Student Union Harry Potter Society.

Viaduct

Rastrick's Viaduct in Brighton was built across fields in the Preston Road section of the valley of the Wellesbourne stream, which is now channelled underground in Brighton. The viaduct is surrounded by Victorian houses and roads but when first built in only a remarkable eleven months in 1845–46 it provided artists a focus every bit as beautiful as the still rural Balcombe Viaduct today. It takes its name from John Urpeth Rastrick, who also built its Balcombe sibling, and is also known as 'Brighton Viaduct' or the 'London Road Viaduct'. It has survived being bombed in 1943 by the Luftwaffe, endless graffiti and the fumes and vibrations of decades of heavy London Road traffic. It remains an underrated and rather beautiful piece of Victorian engineering and architecture. Its twenty-seven arches and 10 million bricks remind us that Brighton owes much to the railways and is a town of hills and valleys. When combined with Brighton's other

The viaduct today, taken from Argyle Road.

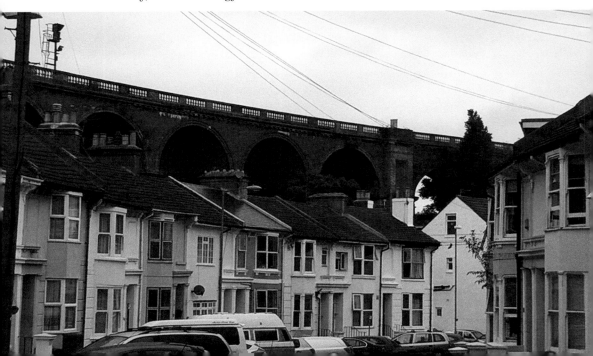

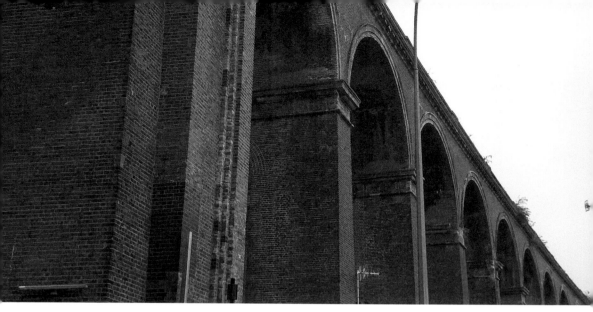

Part of the viaduct's 10-million plus bricks.

brickwork behemoths, St Bartholomews's Church and the Metropole, we have a rich and lasting joint testimony to the talents of Victorian builders.

Volk, Magnus

The city's greatest ever inventor and creator of Volk's Railway gave us not just the 'Daddy Long Legs' but the world's first and oldest continually running electric passenger railway. His father was from Germany but one of his ancestors on his mother's side was William Maynard, one of the Sussex martyrs burnt at the stake in the High Street in Lewes on the orders of 'Bloody' Queen Mary in June 1557. Mary wasn't happy with Maynard's death as his maid was also ordered to be burnt, along with Brighton brewer Deryk Carver. Moving to the 1800s and 1900s, Magnus and his wife Anna moved home in Brighton no less than fourteen times.

Brighton's amazing Brighton and Rottingdean Seashore Electric Tramway, Volk's seagoing railway (better known as the Daddy Long Legs), is the only tramline ever to carry lifejackets for all its passengers and a lifeboat as standard practice. But then, nothing about this railway that ran through the sea was ordinary. Opening in 1896, it was a scary mix of electricity and water, the only railway service that went slower at high tide as the sea slowed it down and its rails were actually under water. King Edward VII rode on it, and it is said to have inspired H. G. Wells to create the aliens in *War of the Worlds*. Magnus Volk short-sightedly never insured the railway and storms that made it topple over led to its demise early in the twentieth century. The carriage, formerly known as the Pioneer, stayed moored to one of the service's piers at Ovingdean before being sold to the Germans for scrap in 1910. The metal most likely ended up being used in the German war effort, a sad end to this forward-thinking railway, which has never been recreated anywhere in the world since. Brighton is the only place ever to have a portable pier.

Wagner, Arthur

Vicar of Brighton Arthur Wagner, back in Victorian times, dedicated much of his time to building churches such as the mighty St Bartholomew's in Ann Street and also helping 'fallen women'. At the time Brighton had a reputation for ladies of the oldest profession in Victorian times with both Valley Gardens and New Street by the Theatre Royal being remarked upon for the large numbers of ladies offering their services. A century later, Brighton gained a vicar who presumably wouldn't have batted an eyelid at any vice the city had to offer. Canon John Hester took over the role Wagner had held a century earlier, and his earlier parish made Brighton look like Hay-on-Wye. Before moving to Brighton in 1975, he had previously been rector of Soho, where his parish contained numerous porn shops and fifty strip clubs.

St Bartholomew's Church.

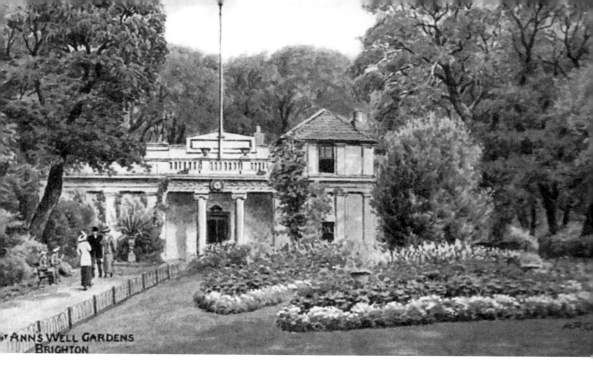

ST ANN'S WELL GARDENS
BRIGHTON

St Anne's Well Gardens. The discovery of a chalybeate spring here helped Russell's rebirth of Brighton as a health resort.

Water

Sussex has been known for centuries for the medicinal properties of its seawater, but did you know we also have chalybeate springs from which water bubbles up to the surface and that is to cure the sick? St Anne's Well Gardens in Hove was discovered to have a chalybeate spring, the mineral properties of which helped Brighton grow as a resort for health. On the other side of the Downs, Ditchling also had one that was famed for helping Sussex folk fight rheumatism and other ills. The spring was famous in the 1800s but had gone out of fashion by the twentieth century. You can still see spring water emerging fresh from under the chalky Downs at Fulking by the wonderful Shepherd & Dog pub, and Brighton's very own hidden river starts under the Downs at Patcham – the Wellesbourne. Icy spring water trickles out from under the beach at Brighton that you can spot east of the Palace Pier.

Xmas

Brighton not only does Xmas on a big scale with our hotels in full swing, our shopping streets gaudily decorated and shops humming, but we also have, as organisers Same Sky have said, the perfect 'antidote to increasing commercialism at Christmas'. Burning of the Clocks is a unique annual secular Brighton event that celebrates the winter equinox and attempts to light up Brighton on the longest, darkest day of the year. It originally started in Preston Park but is now a parade down to the seafront that is open to all and survives on business support and crowdfunding. The idea is a simple one: carry fire or set fire to a clock-related paper construction on the beach to mark the passing of time and to focus your wishes for the forthcoming year. It is a wonderful and non-profit making way of celebrating the nights finally getting shorter after a long dark autumn and the weary winter months. *BN1* magazine quite rightly describes it as 'uplifting', and 20,000 people usually watch or participate in the parade. It is a special event that only works due to the generosity of people funding it

Burning of the clocks, Brighton's secular alternative to the consumer excesses of Christmas.

or volunteering to help. Each year there is a different inspiration for the parade, and inspirational is certainly what this procession and burning of lanterns is.

Brighton has also been used to create a recent Christmas tradition – the annual John Lewis advert. In this case it was a well-known East Brighton estate in the middle of a warm August. John Lewis decided to dress up the roads in Whitehawk with snow and CGI to make their famous Christmas advert for 2015. Residents were offered £500 if their houses were used and got to play snowballs in the fake snow in August. Even residents whose houses were to be used and then weren't were offered bottles of wine for their time, although resident Terry Amos was still waiting for his months later in December. The children were delighted to play in the snow, fake or not, as many of the youngest had never seen a white Christmas. The advert cost £1 million to make and meant Whitehawkians not only helped create probably the most talked-about advert of 2015 but also John Lewis's campaign of helping the elderly who were lonely at Christmas. The advert was supporting Age UK, the charity for supporting the elderly in Britain. Only Brighton could appear in a John Lewis Christmas advert filmed in August.

York's, Duke of

The Duke of York's cinema was originally painted blue on the outside but had a singular red light inside the auditorium when it opened in 1910. The cinema had a unique warning system. This was because Brighton fire brigade at Preston Circus in the early twentieth century used to use Duke of York's cinema (which was next door) when they were off-duty. The cinema subsequently had a red light that would flash to alert the film-watching firefighters that their services were needed without disrupting the films for moviegoers. Fast forward thirty years and films could be disrupted by air raids in the Second World War and so what is now the gents' toilet at Duke of York's cinema was the staff's preferred choice as air-raid shelter in those frightening forties.

York Place/Royal York Hotel

York Place around St Peter's was originally called Church View and is nothing to do with the northern city, but due to the fact that the builder of the area was the owner of the Royal York Hotel in Brighton's Steine.

The Royal York Hotel is the YHA today, and this amazing building was originally the Manor House of Brighton in an earlier form and was joined with two other houses collectively known as 'Steine Place'. That house had been constructed of red brick, thought to be in the middle of the 1700s, and was owned by Richard Scrase, the lord of the manor at that time. Its most famous era was when it was redeveloped to become the Royal York Hotel. It was named in honour of the Duke of York (Prince Frederick) who was the Prince Regent's brother. It was also much loved by King William IV and Queen Adelaide, but, like the Royal Albion Hotel, fell into a poor state at the start of the twentieth century, before being rescued by Sir Harry Preston, who sold it for £32,500 to Brighton Corporation. They used it for offices until the twentieth century and renamed it the 'Royal York Buildings'. Many married Brighton couples remember the building fondly as the home of the registry office that they tied the knot at. Reaching its bicentennial in 2019, it is unique as its main building is the only truly Regency era building of its type, and one of a surprisingly small number in Brighton. The Regency era is technically only

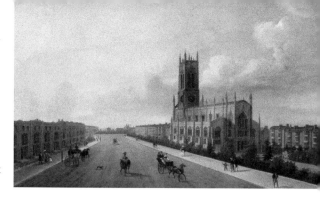

York Place, on the right of this image, took its name from the Royal York Hotel.

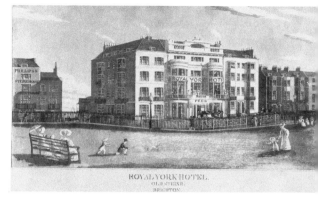

The Royal York Hotel during its first golden age. (Courtesy of Royal Pavilion and Museums, Brighton and Hove)

The Royal York buildings in their current guise as the YHA.

when Prince George was regent, from 1811 to 1820, yet buildings from the 1840s were still built in a later version of this style, such as the Seven Dials area.

It is another literary hotspot of Brighton, having had PM and author Benjamin Disraeli as a resident. Thackeray also graced it with his presence and in 1861 *David Copperfield* was read to audiences there by Charles Dickens. It hit the heights in terms of early aeronautical fame when the aviator Wilbur Wright stayed in the early years of the twentieth century. Harry Pegg became manager in 1827 and enlarged the building so that it gained its east and west extensions. After the Castle Inn (also on the Steine) was demolished in the 1820s, it meant the York and the Ship were the location of the town's most exclusive concerts, recitals and balls. After a recent dalliance as the Radisson Blu Hotel, it now houses the town's seafront YHA.

Zoo

Brighton is far too unorthodox to have something as pedestrian as a zoo. No, we have to have a water-based attraction, built underground by the world's greatest designer of piers, and it would have to be the oldest surviving example of its kind. We are talking here, of course, about Brighton's Sea Life Centre, which is the world's oldest operating aquarium, opening in 1872. It was the brainchild of Eugenius Birch, who also designed and built Brighton's West Pier, as well as numerous piers around the country. He conceived the idea following a visit to Boulogne Aquarium. It was built on the approach

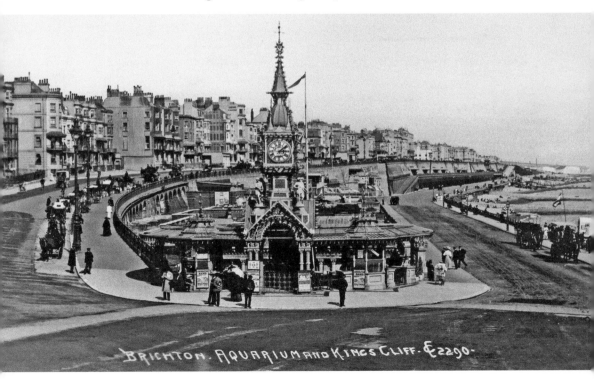

The Aquarium, as Brighton's Sea Life Centre was first called before its rebuild in 1927. (Courtesy of Jackie Marsh Hobbs/Sea Life Centre)

COPYRIGHT.
Frighton Aquarium.— Central Hall.
PUBLISHED ONLY BY
LOMBARDI & Co., 113, King's Road, Brighton.

Above: Aquarium interior again. (Courtesy of Jackie Marsh Hobbs/Sea Life Centre)

Right: The Aquarium interior in its earliest years. (Courtesy of Royal Pavilion and Museums, Brighton and Hove)

roadway to the Chain Pier and was built underground as a legal stipulation decreed its height was not allowed to be over the top of Brighton's East Cliffs.

Back in July 2006 the Sea Life Centre provided us with a subterranean first. Brighton's watery wonder became the first aquarium in the UK to house sea snakes. These serpents each had enough poison to kill three people – and that was just in one bite! Australian expertise was requested to provide an antidote, which had to be sent all the way from down under.

This wasn't the only example of potentially deadly occupiers of the site in its history. Back in the 1970s when it was still called the Aquarium there was an underground shooting range at the far western end licenced for .22 rifle and 'full bore' pistols, used by the Brighton and Hove Rifle and Pistol Club. The butts backed on to the public toilets, which were under the arches. The gents' urinals were the other side of the butts' protective steel plate, which must've caused many a 'relieving' gentleman to wonder what the unusual noises were on the other side of the porcelain. The club stopped using the Aquarium after the Dunblain tragedy. It also stopped being the home for dolphins after pressure from campaigners, and the dolphins briefly were moved to Worthing's Lido before being set free in 1991. No record of what happened to them post-release exists. Now, like the Aquarium's dolphins, you too are free to go and explore the great city of Brighton and Hove. And no, you don't have to start at A with the Albion or the Aquarium. However, if you want a tour guide to accompany you for an 'A-Z of Brighton and Hove' walking or motorized tour, please call All-Inclusive History on 07504 863867 or email info@allinclusivehistory.org. Other tours are available including 'Saucy Sussex', 'Silly Sussex' and 'Spooky Sussex'. All-Inclusive History also run a range of Sussex and Brighton-based events for businesses, organizations and schools. Best of all, they even do a tour called 'A–Z of Brighton'.

Acknowledgements

I am most grateful to Angeline Wilcox at Amberley Publishing for commissioning the book and for her help throughout, as well as the creative endeavours of Jenny, Marcus and Becky with the design and layout. Tim Carder, author of the original *Encyclopaedia of Brighton*, was also supportive, so many thanks to him. Thanks to John Honeysett for prompting my investigations into Brighton FC (rugby club) and to Amanda Jane Scales for her research on Bernard Butcher. Thanks to the Metropole, Sea Life Centre and Jackie Marsh Hobbs, Kevin at the RPAM BAH, and the *Argus*. Finally, my heartfelt thanks as always go to my family, Laura, Seth and Eddie, for their patience, support and encouragement. As Homer Simpson said, 'I've really come to like you guys.'

About the Author

Kevin Newman is a Sussex author, tour guide and historic events organiser who has written five books for Amberley before this one, the last being *Historic England: Sussex*. He has also written school history resources and textbooks. He contributes history supplements and articles to the *Argus* newspaper in Sussex as well as to *Sussex Life* and *Exclusively British* magazines and for Brighton and Hove Albion FC publications. His next book for Amberley is *Pond Puddings and Sussex Smokies: Sussex's Food and Drink*.

Selected Further Reading

Argus/Evening Argus Archives

Armstrong, J. R., *A History of Sussex* (Phillimore, 1978)

Arscott, David, *Curiosities of West Sussex* (SR Publications, 1993)

Arscott, David, *The Sussex Story* (Pomegranate Press, 1998

Antill, Trevor, *The Monarch's Way Book 3: The South Coast, The Downs ... and Escape!* (Meridian Books, 1995)

Barr-Hamilton, Alex, *In Saxon Sussex* (Arundel Press, 1953)

Brandon, Peter, and Short, Brian, *The South East from AD 1000* (Longman, 1990)

Bryson-White, Iris, *History, People and Places in East Sussex* (Spurbooks, 1978)

Bunt, Peggy, *Viewing Sussex Series: Sussex Long Ago* (Warne, 1976)

Coppin, Paul, *101 Medieval Churches of East Sussex* (S.B. Publications, 2001)

Fraser, Antonia, *King Charles II (Part One)* (Orion, 2002 edition)

Gray, James S., *Victorian & Edwardian Sussex from Old Photographs* (Batsford, 1973)

Green, Claire, *Portslade: A Pictorial History* (Phillimore, 1994)

Harris, Roland B., *Brighton and Hove – Historic Character Assessment Report – Sussex Extensive Urban Survey* (Brighton and Hove City Council, 2007)

Harrison, David, *Along the South Downs* (Cassell, 1958)

Jamieson, Susan and Gina, *Old-Fashioned Days Out in Sussex* (Snake River Press, 2009)

Kramer, Ann, *Sussex Women: A Sussex Guide* (Snake River Press, 2007)

Long, David, *Bizarre England* (O'Mara, 2015)

Longstaff-Tyrrell, Peter, *Front-Line Sussex: Napoleon Bonaparte to the Cold War* (Sutton, 2000)

Lucas, E. V., *Highways and Byways in Sussex* (1903)

Mais, S. P. B., *Sussex* (Richards Null, 1937)

Manley, John, *Atlas of Prehistoric Britain* (Phaidon, 1989)

McCarthy, Edna and Mac, *East Sussex: 28 Walks Reprinted from the Evening Argus Weekender* (Southern Publishing Company, Westminster Press, 1984)

Nairn, Ian, and Pevsner, Nikolaus, *The Buildings of England: Sussex* (Puffin, 1965)

Newman, Kevin, *50 Gems of Sussex* (Amberley, 2017)

Newman, Kevin, *Brighton and Hove in 50 Buildings* (Amberley, 2016)

Newman, Kevin, 'Brilliant Brighton' in *The Argus* (2016)

Newman, Kevin, *Secret Brighton* (Amberley, 2016)

Newman, Kevin, 'Super Sussex' in *The Argus* (2017)

Newman, Kevin, *Visitors' Historic Britain: East Sussex/Brighton and Hove* (Pen and Sword, 2018)

Newman, Kevin, *Visitors' Historic Britain: West Sussex* (Pen and Sword, 2018)

Newman, Kevin, Walsh, Aaron, and Holmes, Jon *AQA GCSE History: Thematic Studies* (Oxford, 2016)

Venning, Timothy, *The Kings & Queens of Anglo-Saxon England* (Amberley, 2013)

Victoria County History 'Sussex' – various

Waugh, Mary, *Smuggling in Kent & Sussex 1700–1840* (Countryside Books, 1985)

Willard, Barbara, *Sussex* (Batsford, 1965)

Willy, Frank, and Dale, Judith, *A Short History of Hove* (East Sussex County Council, 1978).